RUSSIAN
FOLK ART
PAINTING

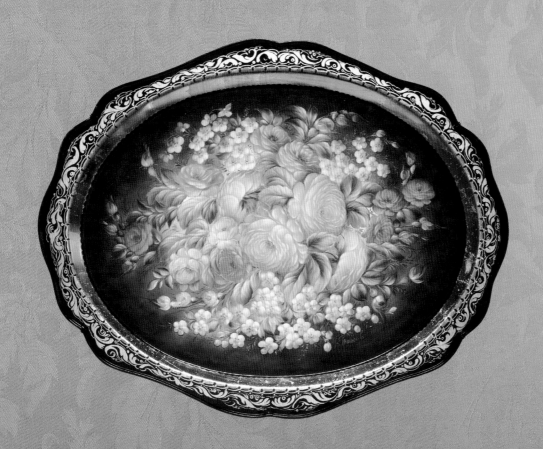

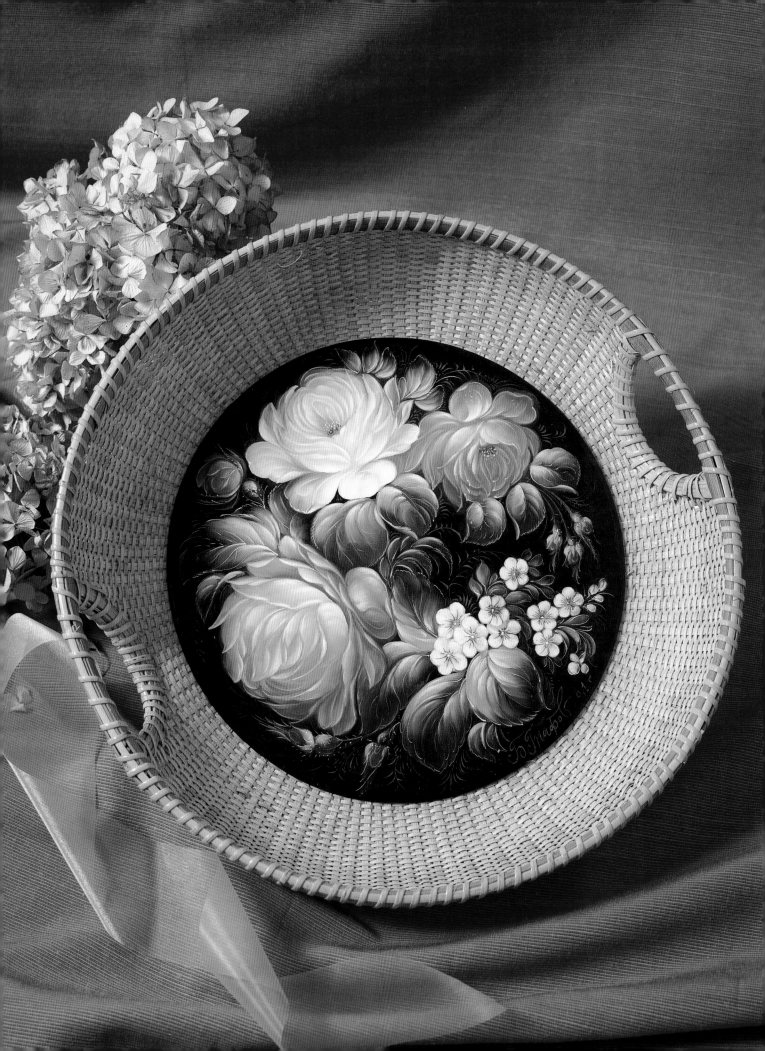

RUSSIAN Folk Art PAINTING

Boris Grafov

with

Priscilla Hauser

Sterling Publishing Co., Inc.

New York

PROLIFIC IMPRESSIONS PRODUCTION STAFF:

Editor in Chief: Mickey Baskett
Copy Editor: Sylvia Carroll
Graphics: Dianne Miller, Karen Turpin
Styling: Mickey Baskett
Photography: Jerry Mucklow
Administration: Jim Baskett

Library of Congress Cataloging-in-Publication Data

Grafov, Boris
 Russian folk art painting / Boris Grafov with Priscilla Hauser
 p. cm.
 Includes index.
 ISBN 0-8069-6857-5
 1. Painted trays--Russia (Federation)--Zhostovo. 2. Tray painting--Technique
 3. Flowers in art. I. Hauser, Priscilla. II. Title.

NK9530.G73 2002
745.7'23--dc21

2002066868

10 9 8 7 6 5 4 3 2 1

Published by Sterling Publishing Company, Inc.
387 Park Avenue South, New York, N.Y. 10016

Produced by Prolific Impressions, Inc.
160 South Candler St., Decatur, GA 30030

© 2002 by Prolific Impressions, Inc.

Distributed in Canada by Sterling Publishing
c/o Canadian Manda Group, One Atlantic Avenue, Suite 105
Toronto, Ontario, Canada M6K 3E7
Distributed in Great Britain and Europe by Chrysalis Books
64 Brewery Road, London N7 9NT, England
Distributed in Australia by Capricorn Link (Australia) Pty. Ltd.
P.O. Box 704, Winsor, NSW 2756 Australia

Printed in China

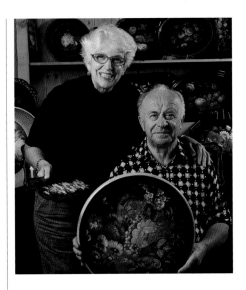

Priscilla Hauser

Master Decorative Painter

Priscilla Hauser has been teaching and promoting decorative painting for more than 40 years. She has appeared on numerous television shows, has written hundreds of books and magazine articles, and has traveled the world to learn about the history and techniques of all forms of decorative painting.

It was during an educational trip to Russia to learn more about their decorative painting, that Priscilla discovered Boris Grafov and the charming town of Zhostovo where he was a master painter in a tray factory. Enchanted with this lovely Russian folk art form of decorative painting, Priscilla was

Continued on next page

determined to bring this art to the United States. In 1992, Priscilla made it possible for a group of Russian painters from Zhostovo to come to the annual convention and trade show of the Society of Decorative Painters. Many painters fell in love with this art of floral painting and have been students of this work since. Boris became such a popular teacher that Priscilla continues to bring him to the United States each year to teach classes at her "Studio by the Sea" in Florida.

Not only has she introduced the oil painting technique to students – but she has been able to convert the technique for use with acrylics. With the help of Priscilla's teaching skills anyone can learn this beautiful floral painting art.

For more information about classes at Priscilla's Studio by the Sea, see her website at www.priscillahauser.com.

JENNIFER DUNAWAY
Project Coordinator

SPECIAL THANKS TO:
Jennifer Dunaway for her marvelous work on this book. Jennifer oversaw this project, working with Boris on his projects, worksheets, patterns, and text.

ABOUT THE ARTIST
Boris Grafov

Boris Vasilyevich Grafov is known as an honorable Merited Artist of Russia. He has been decorated with medals of the Academy of Arts, and has won diplomas and awards at numerous exhibitions of different levels in Russia. His acclaim has also reached the world outside of Russia. Boris was one of six artists who were chosen to go to Belgium in 1958 to represent Russian art. He won a Silver Medal for his work. His work is highly valued in the United States where he teaches and sells his work to collectors.

Mr. Grafov. studied at the Zhostovo school in Russia from 1947 to 1950. He worked two more years as an artist in the factory before taking a four year leave to serve in the Navy. Upon returning to the school he took a leadership role. Boris has been Zhostovo's permanent Artistic Director and Chief Artist since 1961.

Boris has received many medals from the National Artist of Russia Awards.

1959- Gold Medal and two Silver Medals 1970- Gold Medal
1978- Silver Medal 1996 - Gold Medal

In Russia, Boris is a national treasure. His works are stored as a national treasury and exhibited by major national museums. It is with great pride and admiration that we introduce Boris Grafov's techniques and work in this book.

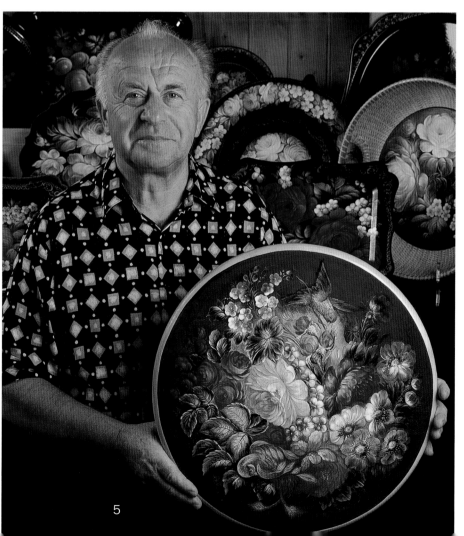

5

Zhostovo is one of the centers of development of a unique type of Russian folk art. Under the brushwork of the Zhostovo artists of our small little town outside of Moscow, simple pieces of metal are transformed into great pieces of art. The people of our village have combined years of tradition and knowledge to create the elegant ornamental and decorative artwork that is enjoyed today.

In the past 10 years, Priscilla Hauser has brought a collection of artwork from Zhostovo to the attention of many painters all over the world. Zhostovo caught the attention of Priscilla, who is a very distinguished artist in her own land and throughout the world, after she came to visit our village in 1992. Priscilla has brought me into her Studio by the Sea in Panama City, Florida and single handedly sparked the rebirth of our traditional art form. Priscilla Hauser invites artists to the studio where they learn the traditional style of Zhostovo painting. After a few weeks of study, the artists feel the Zhostovo spirit in their heart and they strive to develop it in their own artwork after they leave.

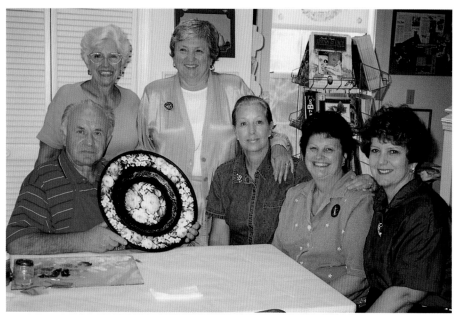

This is Boris during one of his classes at Priscilla's Studio by the Sea. Left to right: Boris Grafov, Priscilla Hauser, language interpreter Oksana Hagopian, Heather Redick, Jan Shaw, and assistant teacher Jennifer Dunaway.

The art itself is very democratic, it has no boundaries or borders, and it has always been this way. To be knowledgeable in the art of Zhostovo, you need very little education. The large expansion of American flora, birds, fruits, berries and growing ornamentation help develop a wider range of composition which the artist can use to create beautiful pieces of art. America is an open field, a field to absorb and use for new ideas.

In Priscilla's studio there is a comradeship of international allure. Artists come from all over the world – Russia, Australia, Argentina, South America, Canada, Japan and other countries – to share their knowledge with each other and to learn. All of their wisdom, together with generations of tradition, leads each of them to adopt an individual style. Demonstrations and lectures are given and videos are shown as artists study this unique art form.

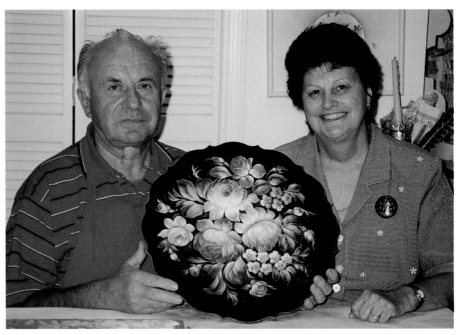

Jan Shaw is from Australia and travels to the United States to learn from Boris. Jan teaches the Zhostovo technique to students in her country and throughout the world. She has won many honors for her magnificent art.

The Studio by the Sea is a cornerstone for the rebirth of the Zhostovo art. Hopefully the composition and my presentation in this book in the style of Zhostovo will help my students develop even more.

This book represents happiness, love, harmony, life, feelings of holidays, and poetic expressions, and it calls out to everyone to try it. *Boris Grafov*

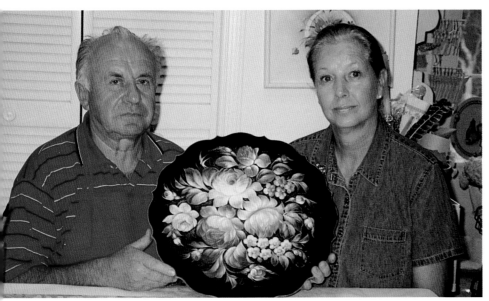

Heather Redick is an artist and teacher from Canada. Heather also is a student of Boris and Zhostovo. She has written several books on this art and travels the world teaching her style of painting.

CONTENTS

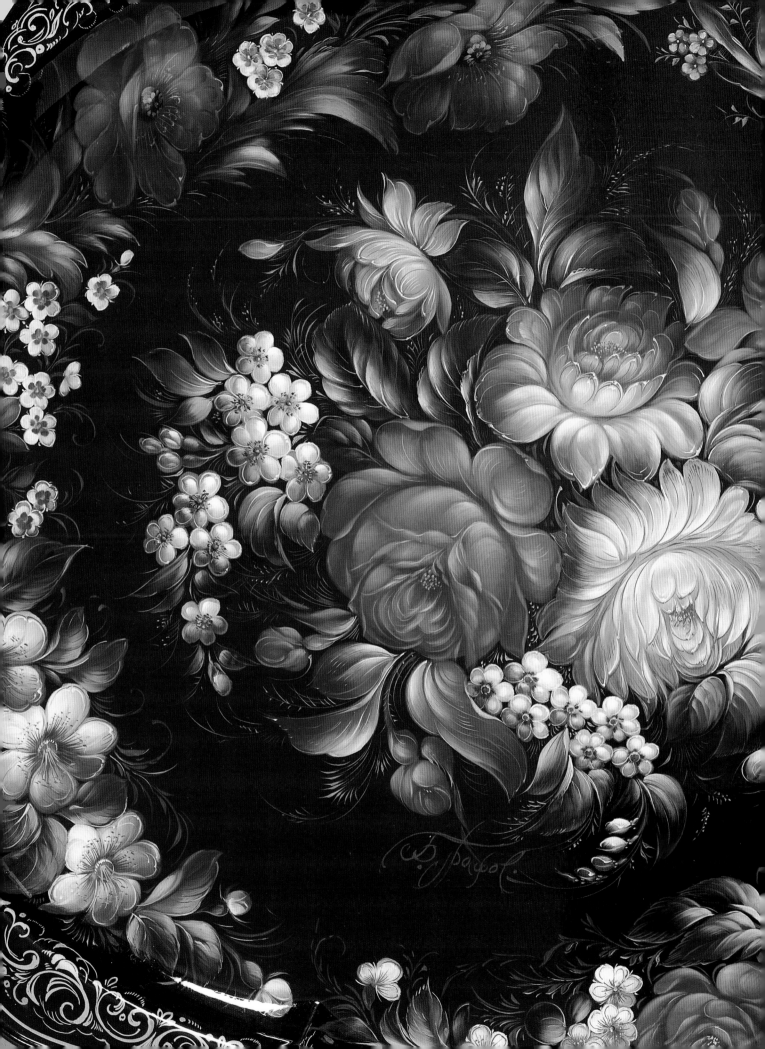

What is Zhostovo Folk Art Painting?

It was in the village of Zhostovo (pronounced jhos-to'-vo) right outside Moscow that a beautiful style of Russian folk art bloomed. This village is known for its beautiful lacquered metal trays bearing bright floral bouquets painted on dark (usually black) backgrounds. The painted trays are sometimes further embellished with ornamental borders or trim painted with metallic gold or silver.

The art of Zhostovo dates back to the early 19th century. At first they painted items which they made of lacquered papier mache. The early craftsmen opened their first shop in 1825 and offered their hand-made and hand-painted boxes, cases, snuff boxes, and other items, including trays which at that time were also made of papier mache. In addition to floral decoration, these early pieces also featured landscapes, genre scenes, and troika driving (a "troika" is a Russian carriage or sleigh).

They later turned their attention to the metal trays for which they are most well-known. On these they painted realistic garden and field flowers in bouquets and garlands, but the bunches of flowers became the most popular and that is the type of design that is still painted today. The style is fresh, direct, and heart-felt, containing the folk art soul within the realistic paintings.

The skilled craftsmen brought the highest artistic quality to these true-to-life subjects. This is still true of today's Zhostovo artist. Each is one of a kind as each master preserves the best traditions and combines them with his own unique expressions and improvisations.

Today Zhostovo art can be seen throughout the world in homes, exhibitions and museums. The current artists are no longer confined to the village of Zhostovo, as the popularity of the art style itself, not just the finished items, has spread to various other parts of the world including the U.S.A. Nor is today's artist necessarily confined to all the traditions of the art form. While most current artists paint it in the same traditional manner with the same materials, the art has also been modified in some areas to obtain similar appearances with the more modern acrylic paints.

We think you'll agree that this Russian folk art is some of the most beautiful in the world. It's a style we think you'll thoroughly enjoy learning.

Gallery
of Russian Art

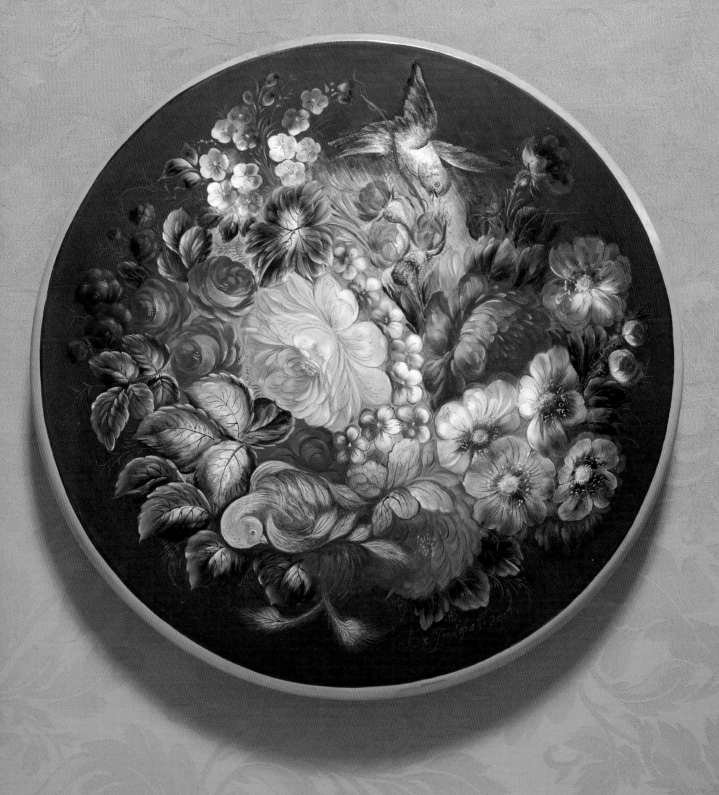

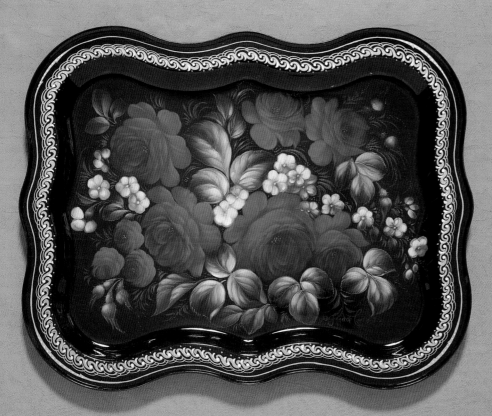

From the collection of Justin & Cole Lawson

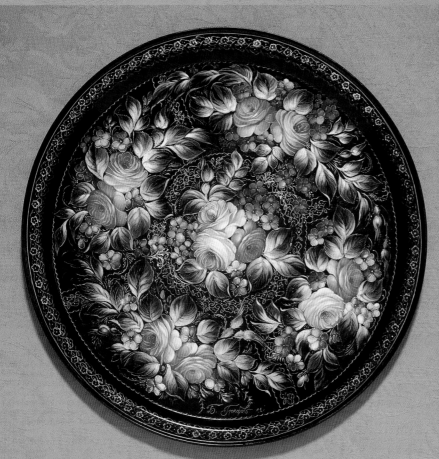

From the collection of Lauren & Logan Lawson

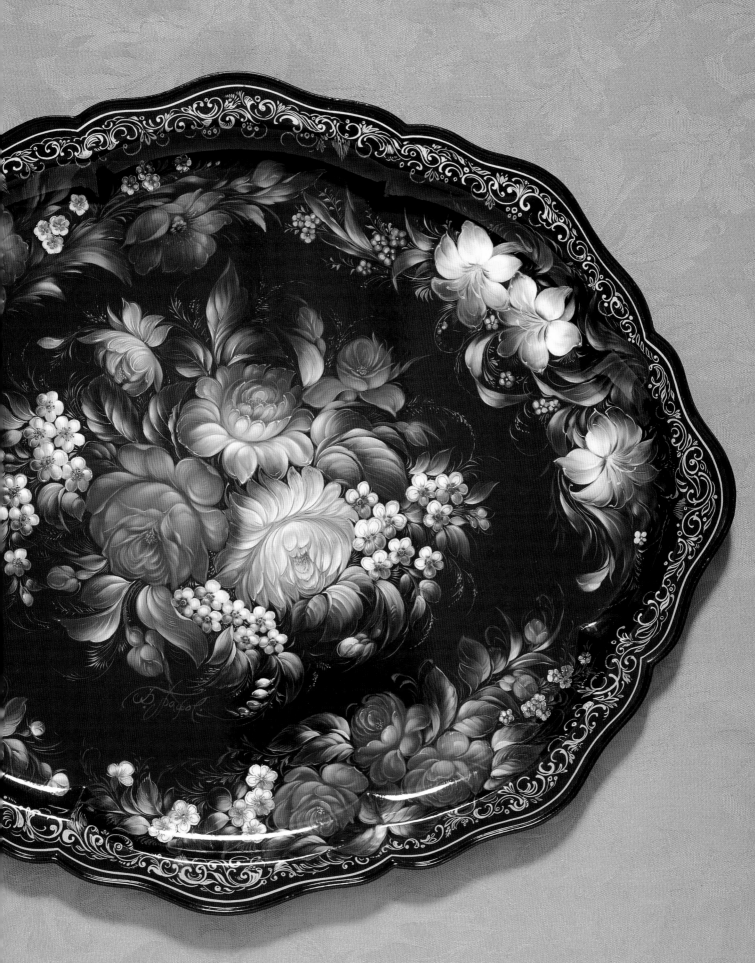

From the Collection of Priscilla & Jerry Hauser

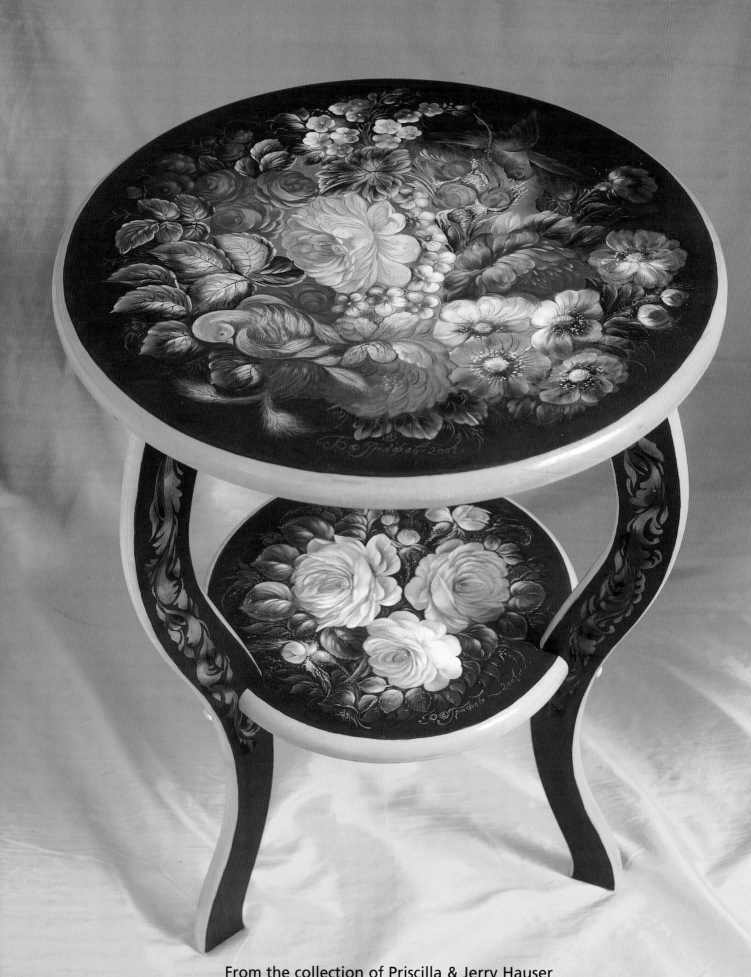

From the collection of Priscilla & Jerry Hauser

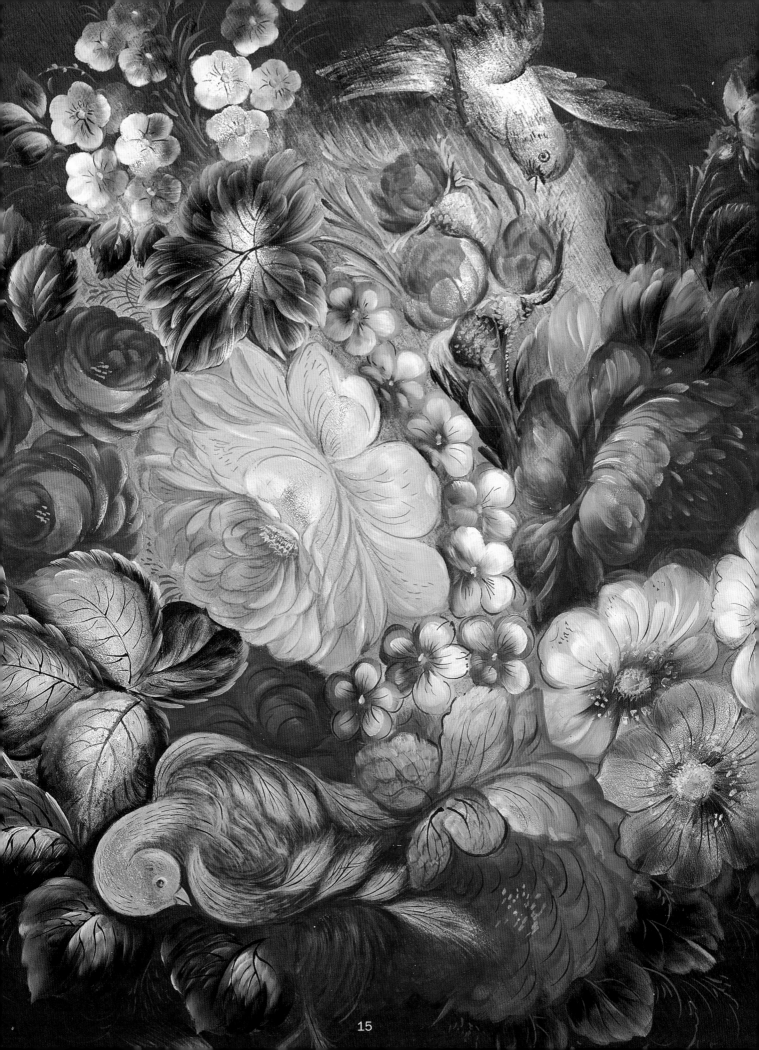

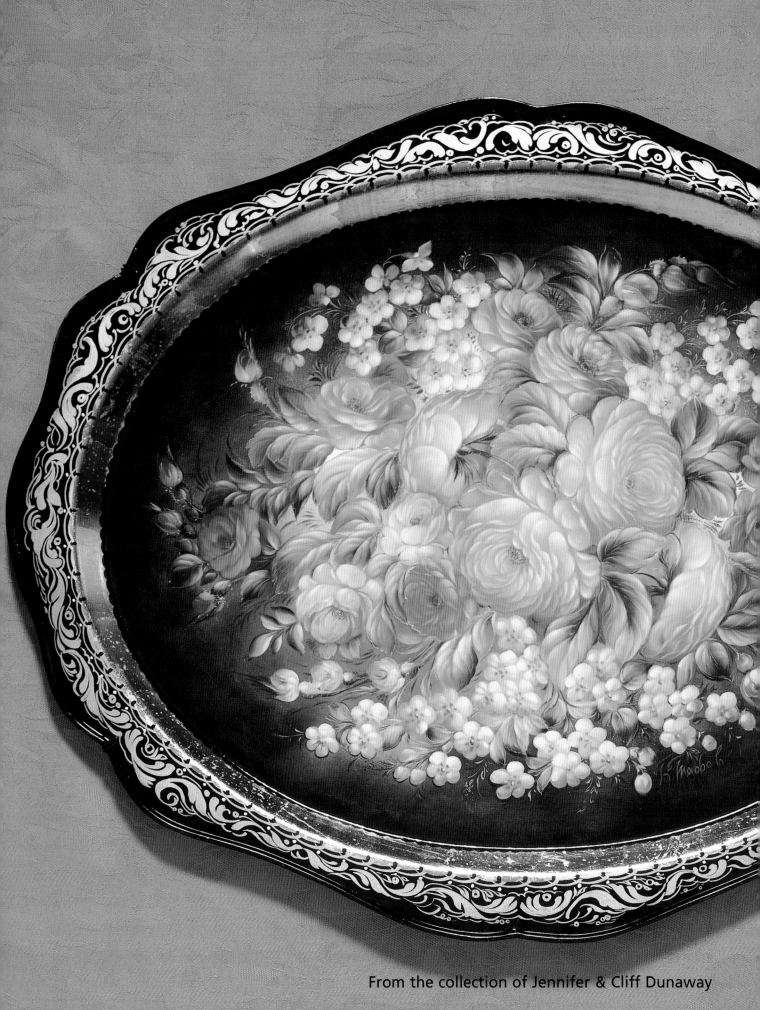

From the collection of Jennifer & Cliff Dunaway

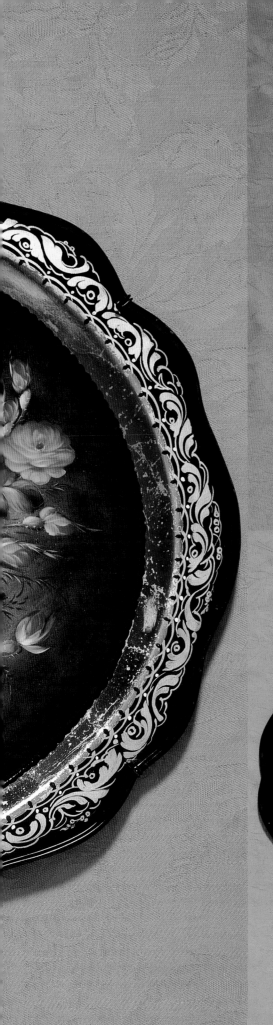

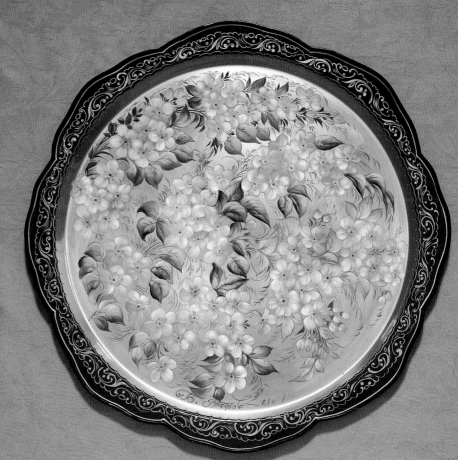

From the collection of Elizabeth Ziliotto

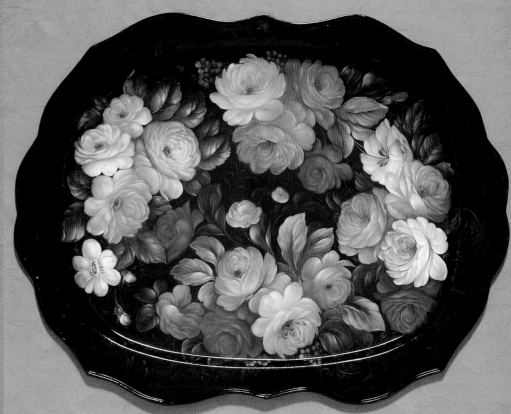

From the collection of Stephany Lawson

17

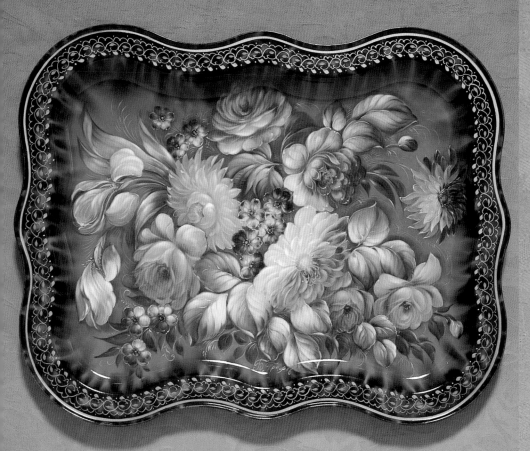

From the collection of Jennifer & Cliff Dunaway

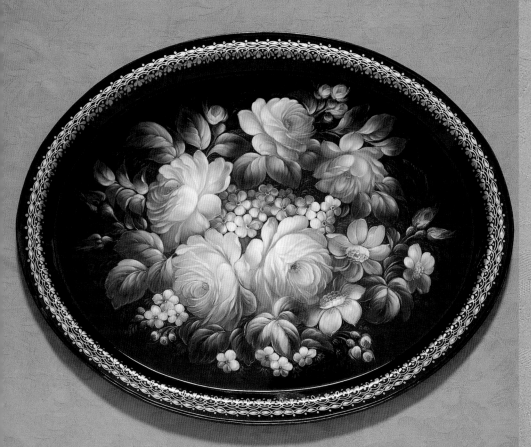

From the collection of Patricia Ake

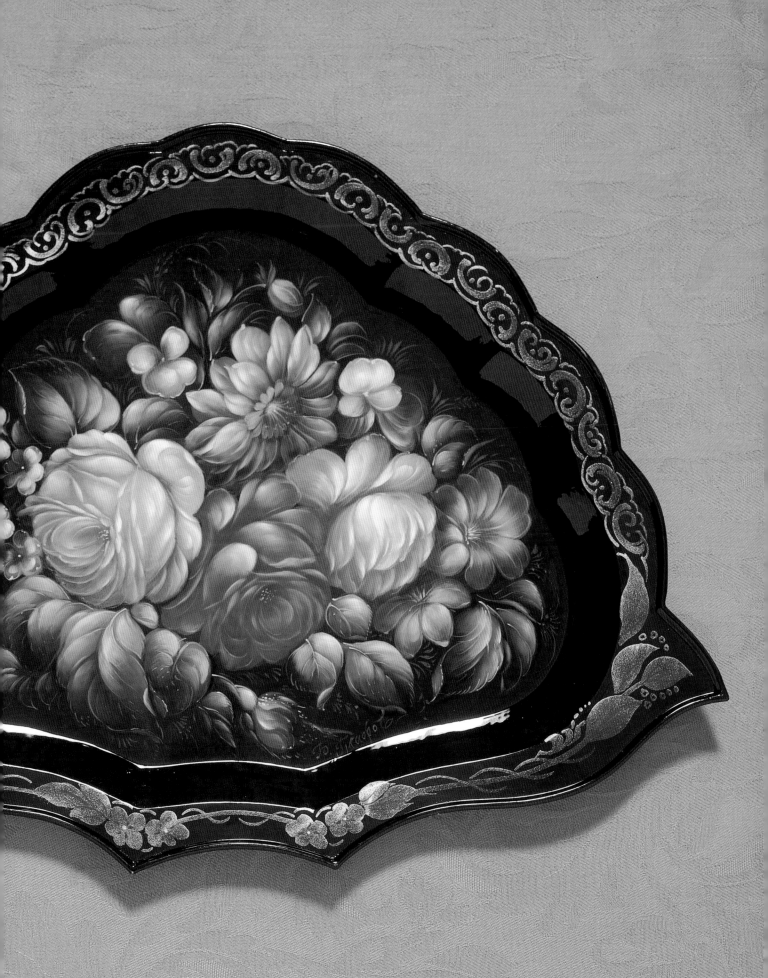

From the collection of Ava & Sara Dunaway

19

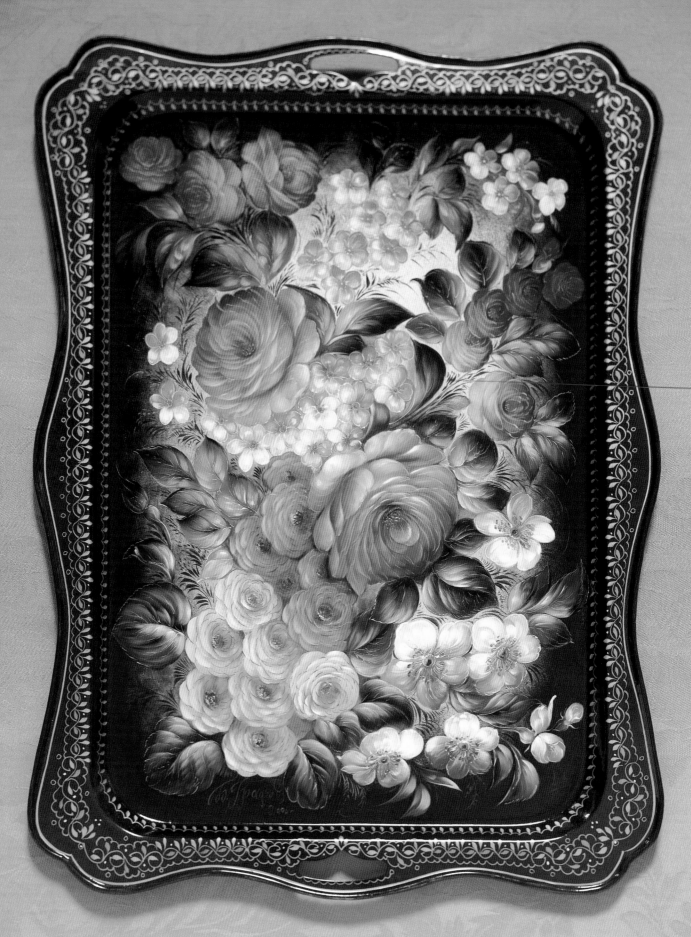

From the Collection of Jennifer & Cliff Dunaway

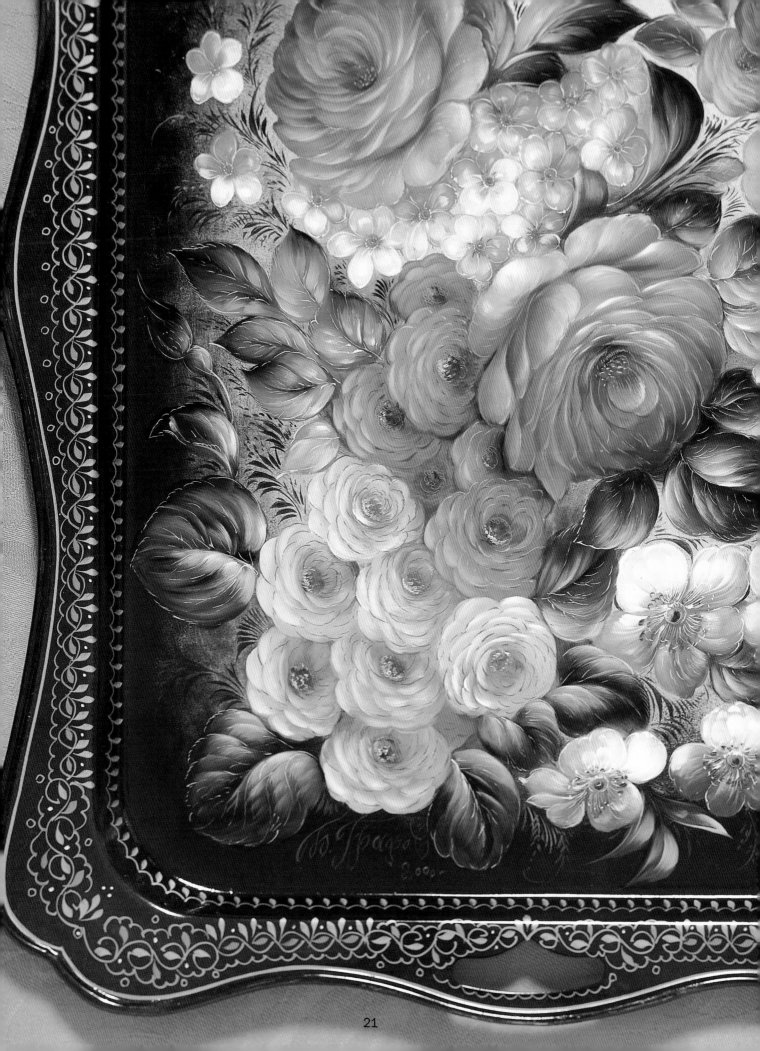

Supplies for Russian Painting

Throughout history, Zhostovo artists have used oil paints to create their beautiful pieces of art. Today many of the techniques can be painted with acrylics. The results will not look as authentic, but can nevertheless be lovely. This book presents mainly the authentic oil painted methods, but covers the use of acrylics as well.

Paints, artist brushes and a few additional supplies as listed in this chapter will get you started on this wonderful journey into Zhostovo painting.

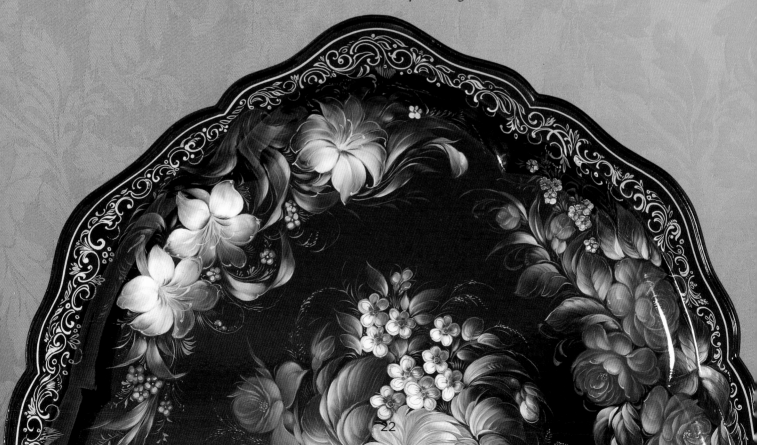

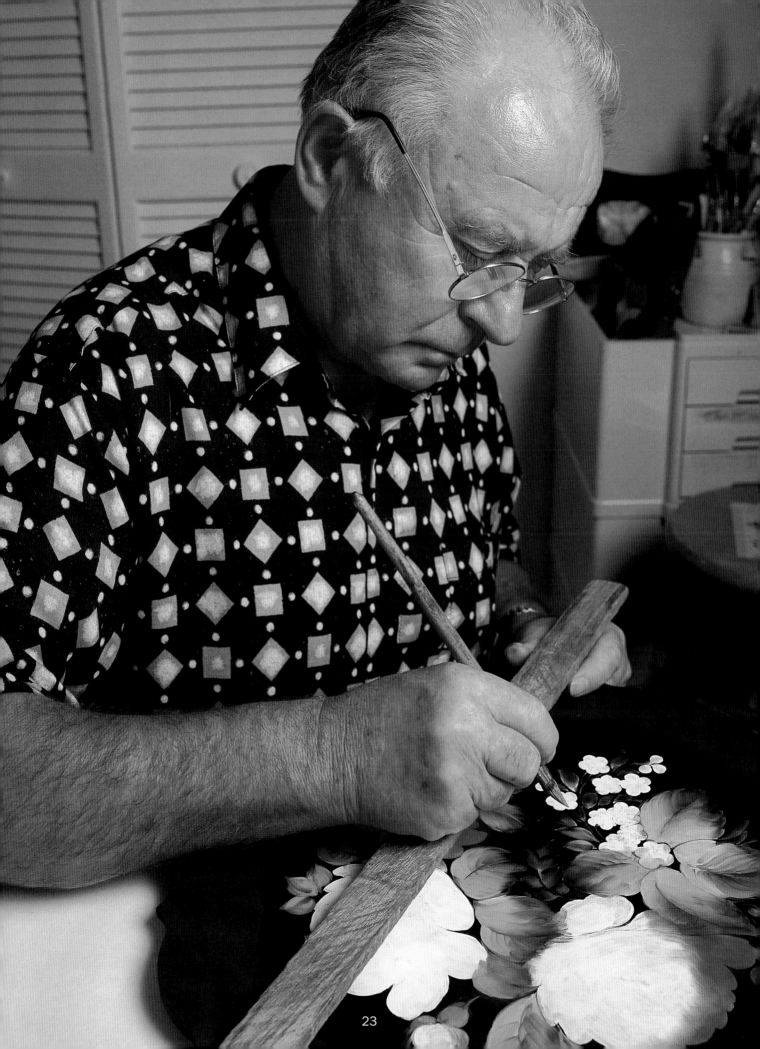

Paint FOR THE COLOR PALETTE

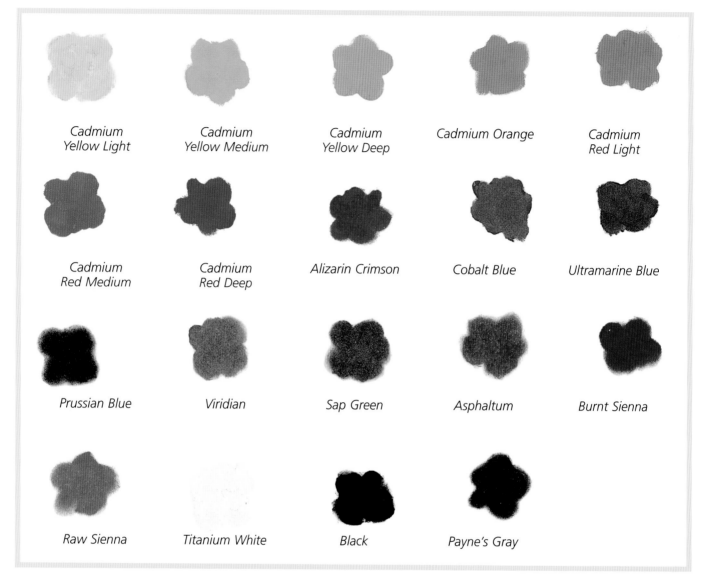

Cadmium Yellow Light	*Cadmium Yellow Medium*	*Cadmium Yellow Deep*	*Cadmium Orange*	*Cadmium Red Light*
Cadmium Red Medium	*Cadmium Red Deep*	*Alizarin Crimson*	*Cobalt Blue*	*Ultramarine Blue*
Prussian Blue	*Viridian*	*Sap Green*	*Asphaltum*	*Burnt Sienna*
Raw Sienna	*Titanium White*	*Black*	*Payne's Gray*	

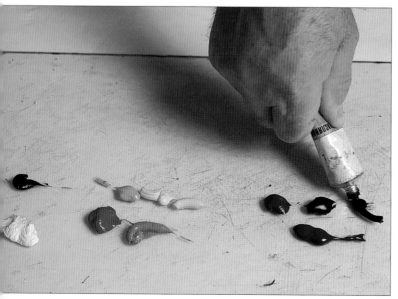

Oil paint was used to paint the projects shown, however acrylic paints can be used.

As for colors, many tube acrylics as well as some bottled acrylics have pigment color names that correlate with the pigment color names given to oil paints. This enables you to easily substitute oils for acrylics. (However, you can not use oils and acrylics together. Either paint the entire painting with acrylics or paint the entire painting with oils.) Undercoating is different – oils can be used to do a painting on top of a dry undercoated acrylic surface.

One more difference is that acrylics have a flat finish while oils have a natural sheen. This is not as noticeable, however, once a varnish is applied to the dried design.

THE COLOR PALETTE

The authentic palette of the Zhostovo artists consist of the following oil colors:

1. Cadmium Yellow Light (CYL)
2. Cadmium Yellow Medium (CYM)
3. Cadmium Yellow Deep (CYD)
4. Cadmium Red Light (CRL)
5. Cadmium Red Medium (CRM)
6. Cadmium Red Deep (CRD)
7. Alizarin Crimson (AC)
8. Prussian Blue (PB)
9. Sap Green (SG)
10. Viridian (V)
11. Titanium White or Zinc White (TW) or (ZW)
12. Asphaltum (ASP)
13. Cadmium Orange (CO)
14. Paynes Gray (PG)
15. Ultramarine Blue (UB)
16. Cobalt Blue (CB)
17. Raw Sienna (RS)
18. Burnt Sienna (BS)
19. Black (B)

If using acrylics for painting the design, the color palette will be the same.

UNDERCOATING THE DESIGN, BASECOATING THE SURFACES & ORNAMENTATION

Most of the Zhostovo floral designs are painted on a dark background. It is important to undercoat the entire design with white before painting the colors. In Russia, oils are used for the undercoating. Because acrylics dry so quickly, we suggest you use a white craft acrylic paint for undercoating. Undercoating with a light color gives illumination to the actual painting when it is completed. In other words, the light reflects through the oil to create an elegant brilliance.

The ornamentation or borders are traditionally done with metallic gold, silver or bronze. Many of our acrylic metallics work beautifully for these borders and dry quickly.

Basecoating the surface of the project may be done using acrylic or oil based paint. However, when painting the design, do not mix oil and acrylic colors. Paint the design with either all oils or all acrylics.

MEDIUMS

A painting medium is a product used with the paint to affect its consistency (thin it), help the paint move or flow, or to affect its opacity.

For oil paints, linseed oil is the usual medium. To make even thinner paint, linseed oil and turpenoid may both be used The thinner you want the paint to be, the more turpenoid you use in the mix.

Painting mediums for acrylic paints include blending gel, floating medium, and glazing medium.

DIFFERENCES BETWEEN OILS & ACRYLICS

There are differences in the use of the two types of paint. One of the most significant differences is drying time – acrylics dry very fast compared to oils. The drying time affects the amount of "open" time the artist has (i.e., how much time the paint can be worked on the surface before drying begins to impede it). Also different painting mediums are used with oils versus acrylics, and different cleaning solvents for your brushes.

Brushes AND THEIR CARE

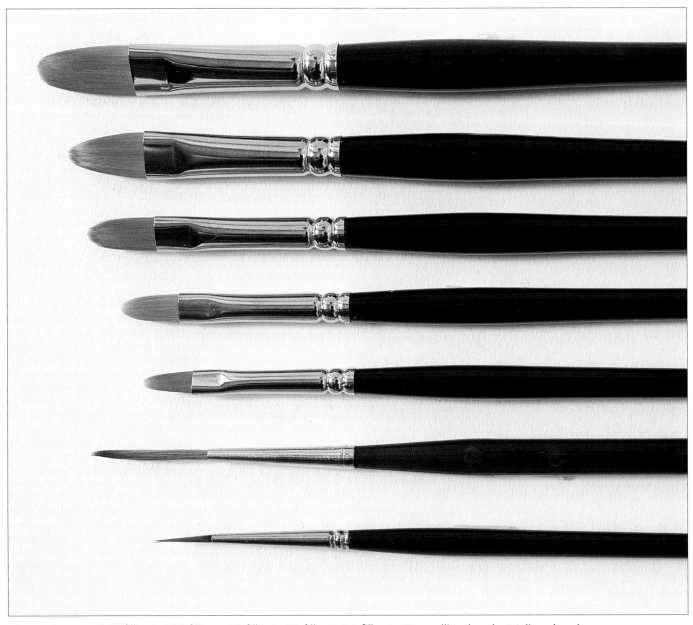

Top to Bottom: #12 filbert, #10 filbert, #8 filbert, #6 filbert, #4 filbert, #2 scrolling brush, #1 liner brush.

Zhostovo painting is done with Russian squirrel hair brushes that are shaped very much like filbert brushes. They are difficult to find in this country and are not available in numbered sizes. They are simply small, medium and large. These brushes must be broken in before use because the more they are used, the smoother your strokes will look. The traditional Zhostovo artist makes his own liner brush. It is a long hair squirrel brush that is trimmed with a razor blade to create a brush that looks something like a wet noodle. It takes a little time and practice to learn to use this brush for linework as well as ornamentation, but the results are excellent.

Filbert brushes are readily available and these can be substituted for the Russian squirrel hair brushes. These synthetic hair brushes are recommended in sizes #2, #4, #6, #8, #10 and #12. Also, an excellent liner or scroll brush is needed.

Brush Care for Synthetic Brushes

Most fine brushes come with a sizing in them – a stiffening agent that keeps every hair in place. Hold the brush between your thumb and forefinger and gently work the brush back and forth. You will notice the sizing flaking out of the brush. Clean the brush in soap and water and dry it before using.

You can dress the brush in linseed oil before you begin painting just as you would the squirrel brushes.

When you have finished painting for the day, clean the brush in turpenoid and wipe on an absorbent towel. Place a small amount of liquid detergent in a container and work the brush back and forth in it until you have gotten every bit of paint out of the brush. Rinse the brush with water until you no longer get paint or soap out of the brush. Put a small amount of clean soap back into the brush and shape the hairs of the brush. When you are ready to paint again, simply rinse the brush in water to remove the soap. Remove the water with a soft absorbent paper towel or cotton cloth.

Brush Care for Squirrel Hair Brushes

New squirrel hair brushes need to be dipped in turpenoid, blotted on a soft absorbent towel and dipped into linseed oil. The oil is worked through the brush by working it back and forth on the glass palette.

Use your brush as often as you can. When you do so, you condition the brush, breaking it in so the brush can actually help you create perfect strokes. After using your brush, if you plan not to use if for just a day or two, you can dress it with linseed oil. If you plan to leave your brush three to five days, dress it with olive oil. If you are planning to store your brush and not use it for a while, dip it into automotive motor oil – yes, the kind you put in your car. This oil will not dry out in the brush. Add a moth crystal to the storage container to prevent pests from eating the natural hair bristles.

Boris suggests that you do not wash these brushes in soap and water because it will interfere with the shape of the brush.

When you take your brushes out of storage with the motor oil in them, dip them in a separate container of turpenoid, then dip into linseed oil. Keep this container of turpenoid separate and do not use it during your painting. If you get the motor oil into your paints, the painting will not dry properly.

Tips:

• All brushes must be in excellent condition in order to perform well.

• If the brush is too frizzy on the edge, rub the brush with a little linseed oil back and forth on a piece of fine grade sandpaper. This will actually sand off the fuzzy edge.

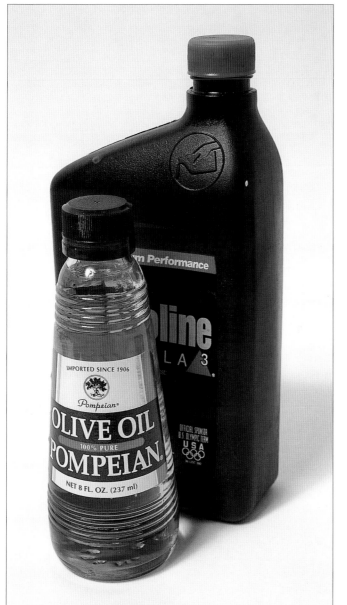

Pictured at left: *Motor oil and olive oil for brush care*

Surfaces AND PREPARATION

Traditionally, Zhostovo painting is done on metal trays. Modern day artists are painting on many different surfaces ranging from furniture to refrigerators. Most of the projects in this book are painted on metal trays. However, wooden plates, bowls, and similar items are also used here very successfully.

SURFACE PREPARATION FOR WOOD SURFACES

When working with wooden surfaces, repair any imperfections with wood filler. Let dry and sand with fine sandpaper. Wipe with a tack cloth.

1. Seal the surface with a brush-on sealer or spray it with a clear matte acrylic spray and let dry.
2. Basecoat with two or three coats of acrylic paint. Sometimes more than two coats of paint are needed, depending on the opacity or transparency of the paint. Between coats, sand the surface with a very light grade of sandpaper. Wipe off the residue with a tack cloth.
3. Seal the surface again with a light coat of sealer or matte spray.
4. Do a final sanding with fine sand paper or brown paper bag with no printing on it.
5. Transfer your pattern following the instructions on page 33.
6. Undercoat only the design with white acrylic paint.

SURFACE PREPARATION FOR METAL SURFACES

If you can, purchase a surface that has been commercially prepared. If your surface is a raw, unprimed tin:

- Wash it thoroughly with a dishwasher detergent and water. Allow to dry.
- Wipe it with vinegar.
- Spray or brush on two or three coats of a flat metal primer paint. If you spray, please make sure you do it outdoors on a warm day in a well-ventilated area. I suggest you wear a respirator or face-mask while spraying. Many light coats of spray are better than one heavy coat.

Here's How:
1. Shake the can.
2. Hold the can 8" to 10" from the surface.
3. Try to spray when the temperature is around 70 degrees. If the temperature is too hot, the spray will dry in the air and will be powdery when it hits the surface. If this happens, you will have to sand the surface with 4/0 steel wool and try to spray again. (In Florida, we have to spray very early in the morning to avoid this problem.)
4. Let dry and sand with very soft steel wool after each coat. Make sure you sand the last coat with a crumpled up piece of brown paper bag with no printing on it. This gives a very smooth surface. Seal with matte acrylic spray. Rub lightly again with the brown paper bag. Wipe with a tack cloth. Let dry and cure.
5. Transfer your pattern following the instructions on page 33.
6. Undercoat the design with white acrylic paint.

Varnishes

Authentic Zhostovo trays have a very high gloss oil based varnish applied over the decorative painting. When using brush-on varnish, apply with a good quality varnish brush. If you are working on a light colored background, be sure to use a non-yellowing varnish. Water-based varnish is another option for using over oil paints. Spray varnish can also be used. When using aerosol, wear a respirator and apply many light coats

Tips for Applying Varnish:
- Be sure the painted tray or other decorative painted item has thoroughly dried and cured before varnishing.
- Before varnishing, rub the painted piece with a piece of brown paper bag with no printing on it to absorb any excess oil that may be on the surface.
- It is best to varnish with both the piece and the varnish at room temperature.
- Lightly sand with a very fine grade of sand paper or steel wool between coats of varnish.
- Three, four, five or more coats of varnish may be applied, as desired.

TIPS:
- Always work in a well-ventilated area.
- It is important to mist many light coats of clear acrylic spray rather than one coat that is too heavy. Do not over-seal the wood and make it so slick that your decorative painting will not adhere!
- Sealing the prepared surface before you put your pattern on will allow you to clean up any errors without disturbing your basecoat.

Working With Acrylics

Artists' tube acrylics are most often found in art supply stores. Craft acrylics are different in formulation than the artists' tube acrylics. Craft acrylics are easy to find in hobby and craft stores. I prefer using the artists' tube acrylics. If acrylic is your paint of choice, the quality of the artists' tube acrylic is best for painting Zhostovo. The undercoating of the design may be done with the craft acrylics.

When using acrylics, you will need a "sta-wet" type of palette. These palettes may be found at most art and craft stores. Acrylic paints dry very quickly, and this palette (when properly prepared) will keep your paints wet throughout your painting session.

A brush basin is handy for rinsing and cleaning brushes used with acrylics.

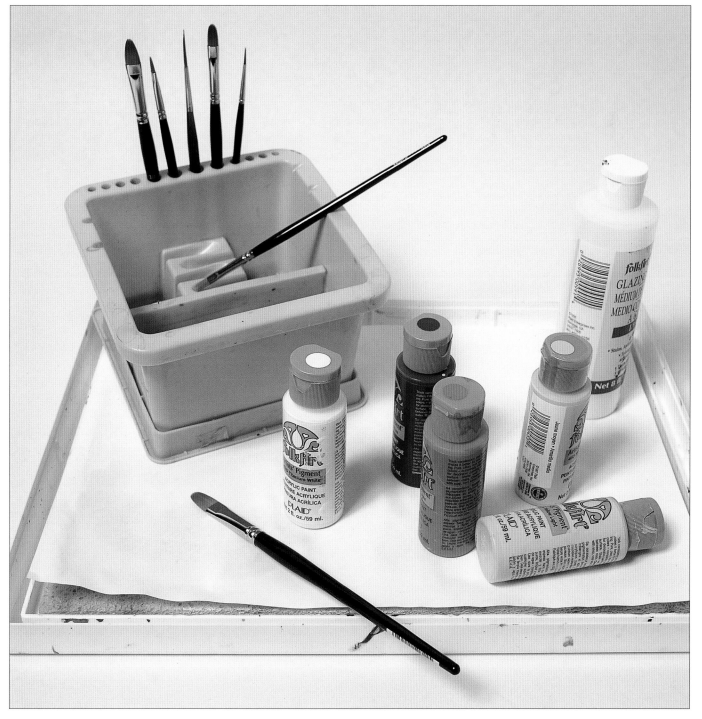

Additional Supplies You Will Need

Glass palette for oils

Sta-wet Palette for acrylics

Palette knife for breaking out your paints and for mixing colors

Color wheel for reference

White and colored blackboard chalk for transferring patterns (Do not buy the dustless kind.)

Stylus for transferring patterns

Eraser for removing unwanted pattern lines

Soft absorbent paper towels or cotton cloths for cleanup

Compass optional for drawing circles

Tack cloth for wiping away sanding dust

A good brush for basecoating

Linseed Oil as an oil paint medium

Olive oil for brush care and storage

Motor oil for preserving brushes between painting sessions

Turpenoid – an odorless, colorless turpentine substitute. It is great for thinning paint, cleaning brushes and removing paint. It has similar painting properties and drying time as turpentine.

Glass jars, one for clean turpenoid, one for cleaning brushes, and one for cleaning motor oil out of the brushes

Sandpaper and **brown paper bag** for preparing surfaces

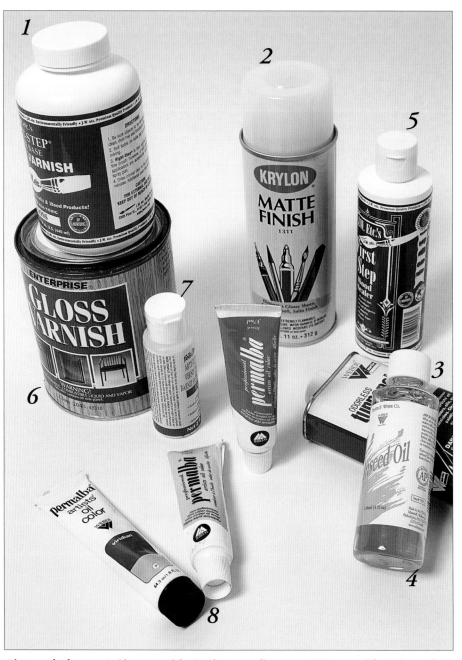

Pictured above: *1.Gloss varnish, 2.Clear acrylic spray, 3.Turpenoid, 4.Linseed oil, 5.Wood sealer, 6.Polyurethane gloss varnish, 7.Blending medium for acrylics, 8.Oil paints.*

Wood Sealer for preparing wood surfaces

Fine steel wool, (0000) for preparing metal surfaces

Clear acrylic spray, matte finish – one option for sealing wood, also used to protect the undercoating before painting the design

Single-edged razor blade to scrape undercoating for smoothness

Bridge to use across the project to keep your arm out of the wet paint

General Information

Before you can run, you must know how to walk. Before you can paint a project, you will need to learn techniques and familiarize yourself with some terms. Over the next few pages, you will learn how to prepare your palette, load your brushes, make various strokes, shade and highlight your designs. Boris will then take you step-by-step through painting a rose and then step-by-step through painting a whole project.

Study this information and practice, practice, practice. Your confidence will build and soon you'll be ready to paint your first tray.

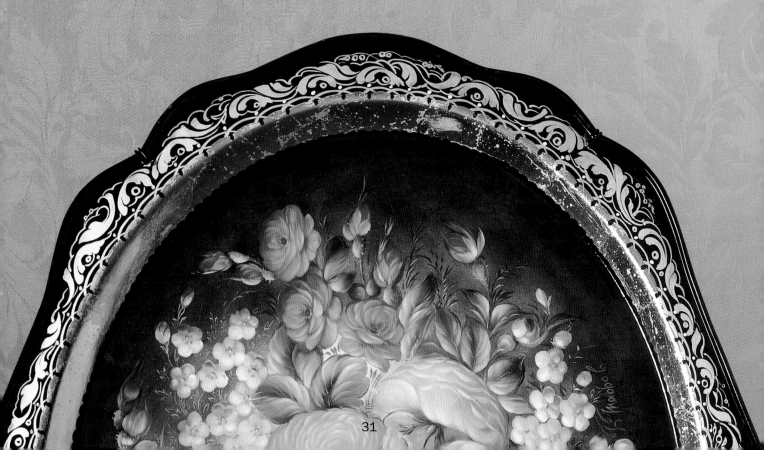

Terms to Know

Artists' Tube Acrylics: These are the fine art tube acrylics found in art and some craft stores. The chemical formulation of these paints is different in many cases than the bottled craft acrylic paints.

Basecoating: The application of acrylic or oil paint applied to the surface of the item on which you will be doing your painting. Several coats should be applied. Sand with a fine grade of sand paper between each coat and wipe with a tack cloth. A smooth, opaque surface is desired before the transfer of the design and painting begins.

Craft Acrylic Paint: Craft paint is used for basecoating. Occasionally, people will use it to paint the Zhostovo designs. In this book, craft paint is only used for undercoating the design.

Dressing the Brush: This means to fill your brush with a painting medium before adding the paint color. For oils, this medium is linseed oil and sometimes turpenoid as well. Acrylic paint mediums are blending medium, floating medium, and glazing medium.

Shading: Sometimes called "shadowing," this is adding a darker color in the areas which receive less light to add form to the object you are painting.

Highlighting: This is adding a lighter color in the areas which receive more light to add form to the object.

Linework: These are the fine lines of a painting – details or outlining painted with a liner brush and thinned paint.

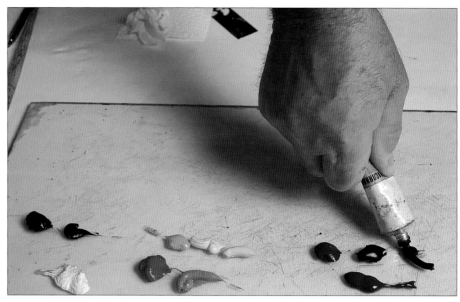

Preparing your color palette.

Stippling: In this work, stippling is to apply small dots randomly throughout an area (such as a flower center), using the very tip of a liner brush.

Brown paper bag: Rubbing the surface with a piece of brown paper bag with no printing on it, actually eliminates the need sanding and it smooths the surface. A piece of brown paper bag is non-abrasive but will do a beautiful job of smoothing a surface.

Grass: Grass refers to the graceful fill-in strokes used around the flowers and leaves in Zhostovo designs. It is generally done with the liner brush and very thin paint.

Tack Cloth: This is a piece of cheesecloth treated with varnish and linseed oil. It is excellent for wiping away sanding residue and lint. You may find them in paint, hardware or craft stores.

Preparing Your Palette

The color palette generally follows the color wheel. Referring to a color wheel for the order, squeeze a small puddle of paint of each color you will need onto your palette. As you use up a puddle of paint, add more as needed in the same spot on your palette.

The artist brush-mixes the oil colors on his glass palette. For instance, if you need an ice blue color, you would pick up some Prussian Blue and some White from the puddles and, in a clean spot on your palette, mix the two colors together with your brush to create the ice blue color.

The project instructions will tell you which colors you will need to put in puddles on your palette. When a mixed color is required, instructions will tell you which colors to mix together to create that color.

Transferring the Design to your Project

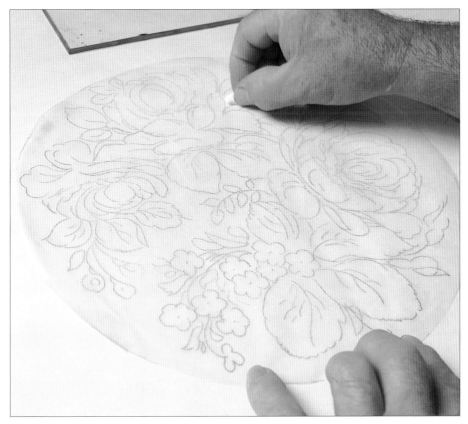

Photo 1

1. Place tracing paper over your design or pattern. Using a fine point marking pen or a pencil, carefully trace the design.
2. Turn the paper over. Neatly retrace the lines of the pattern on the backside of the tracing paper firmly with chalk or a charcoal pencil. Never rub chalk all over the back of the pattern! (see Photo 1)
3. Shake off excess chalk dust, center the pattern on the project surface, and secure it with tape.
4. Retrace the lines with a pencil or stylus to transfer the chalk lines to your surface. Don't press hard enough with the pencil or stylus to make indentations. (see Photo 2)
5. When your design has been painted and allowed to dry, remove any visible pattern lines with a kneaded eraser or a little water before applying the final finish.

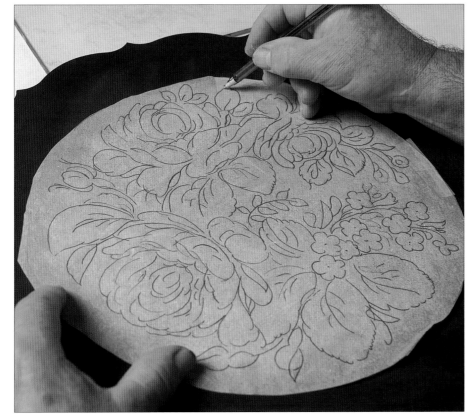

Photo 2

TIPS:

- Graphite or carbon lines often show through your painting and are difficult to remove. They may leave irremovable smudges on the background.

- If your background is medium to dark in color, use white chalk on the back of your tracing paper. If your background is light, use brown or green chalk – a color you can see.

FULL LOADING A BRUSH

1. Clean brush in turpenoid, dip your brush in the linseed oil to dress it, and wipe on a soft absorbent towel.

2. Dip your brush into a small amount of oil paint. The color should flow through the hairs of the brush and not clumped on the outside edge of the brush. The color should only go about halfway up the brush. It should not go all the way to the metal ferrule. (see Photo 1)

3. Brush the paint out on your palette. (see Photo 2)

4. When mixing colors, pick up the desired colors on the brush and mix on the palette.

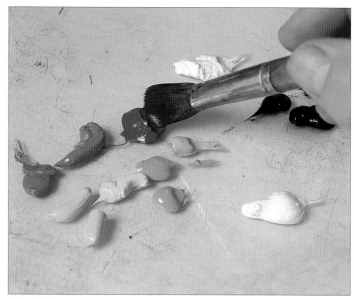

Photo 1

SIDELOADING A BRUSH

1. Dip one side of dressed brush into paint. Sideload the brush by stroking one half to one-third of the brush through a color.

2. Turn brush over and the stroke on the other side of the brush in order to get enough paint in it. Blend on palette. The color should gradually fade through the hairs of the brush from dark to light.

3. Sideloading is used to paint petals on flowers (forming the shapes) or for stroking on highlights on leaves or flowers.

Photo 2

LOADING A LINER BRUSH

A mixture of half turpenoid and half linseed oil is generally used with the oil pigments to create the proper consistency of paint when using a liner brush. However, if a thinner consistency is desired, more turpenoid than oil should be used.

1. Fill the brush completely full by stroking back and forth in your thinned paint. (see Photo 3)

2. Carefully twist the brush in the paint until it forms a fine point.

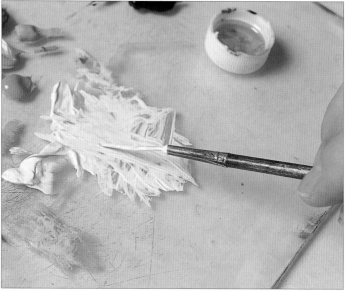

Photo 3

Brush Stroke Painting Worksheet

U-Stroke Variations: Used to make edges of petals.

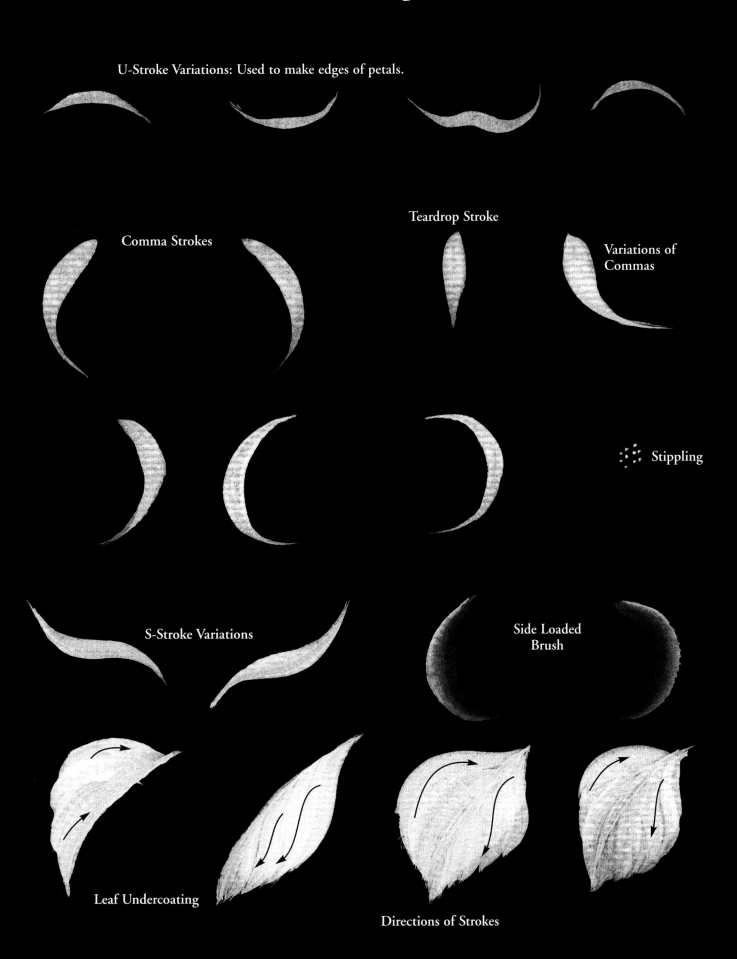

Comma Strokes

Teardrop Stroke

Variations of Commas

Stippling

S-Stroke Variations

Side Loaded Brush

Leaf Undercoating

Directions of Strokes

Undercoating

Undercoating is painting the design solidly with an acrylic craft paint. This allows the colors of the design to be bright and vibrant. In Zhostovo, undercoating is done with oil paints. The trays are then placed into large drying ovens overnight. We can get very similar effects by undercoating with craft acrylic paint and allowing the undercoating to dry before painting.

1. Smoothly undercoat the entire design with white acrylic paint using the directional strokes with which you will paint the design. Let dry. (see Photo 1 and 2)
2. Scrape the surface of the undercoated design lightly with a razor blade so there are no ridges left from the white acrylic paint. (see Photo 3)
3. Rub with a brown paper bag. Wipe off the residue with a soft cloth. (see Photo 4)
4. With a piece of cotton cloth, rub a very thin layer of linseed oil on the design, if you will be painting with oil paints. (see photo 5)

Varnishing

1. Use a soft synthetic brush or a sponge brush to apply the varnish. Let it dry.
2. Apply second and third coats, allowing it to dry after each coat.
3. Sand lightly with a fine grit sandpaper or brown paper bag and wipe with a tack cloth after each coat.
4. Apply a final coat of varnish.

Photo 1

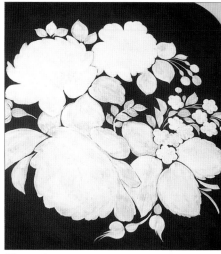

Photo 2

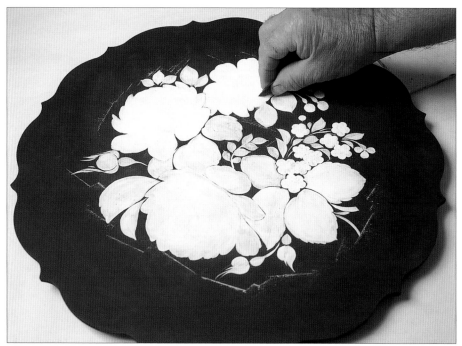

Photo 3

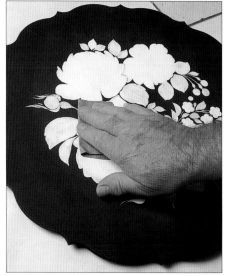

Photo 4

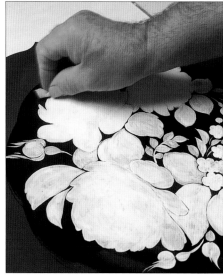

Photo 5

The Overall Procedure

The sequence of creating a Zhostovo's painting is as follows:

1. Sketch or trace and transfer the design.
2. Undercoat the design areas.
3. Rub on a thin coat of linseed oil.
4. Paint the first shadows.
5. Paint the second shadows.
6. Add the medium value color.
7. Stroke in a lighter value and the highlights.
8. Add fine lines in and around the design elements.
9. Add ornamental linework around the design – the grasses.
10. Paint the borders (known as ornamentation).

This process requires many layers of paint. The first layers are very thin and seem like tints on the surface.

Background Colors

Traditional colors for the backgrounds of the trays are dark cherry, dark brown, dark green, dark blue, and, of course, black. Today, there are many variations of these colors. Sometimes they even use a combination of colors, fading one color into another.

LINEWORK TIPS:

- The brush should be full of paint thinned to a flowing consistency.

- When painting linework, the handle of the brush should point straight up toward the ceiling.

- Move the brush slowly, allowing the paint to flow from the hairs of the brush.

TIPS FROM BORIS:
For Keeping Your Colors Crisp and Clean

- Apply one color of the design at the time instead of painting one subject at the time.

- Keep your palette clean by scraping off the muddy paint with a palette knife or razor blade.

- When reloading your brush with paint, first wipe the remaining paint on a cotton cloth.

- Clean your brush in turpenoid and wipe on a soft absorbent cloth between color changes. You may need to add linseed oil to the brush again before picking up the next color.

- If you are having problems keeping your colors clean, use a different brush for each color.

- Use clean turpenoid when mixing colors or thinning the paint consistency.

Stroke Linework & Ornamentation

See Examples on pages 38 & 39

Zhostovo's traditional linework is used in a number of different ways. One form is the creation of beautiful, very thin and flowing filler strokes, often referred to as "grasses." These graceful, flowing lines are painted between leaves and often around the petals of flowers to fill in and soften the painting.

When Boris paints the grasses, he usually mixes together several colors from his palette to make a gray color. Sometimes it is a gray-blue or gray-brown. By mixing together colors used in other parts of the design, the grass color always relates to the rest of the design.

Linework is also used to embellish flower petals, flower centers, stems, buds, and leaves. Linework can only be created if the liner brush is full of paint that is a thin and flowing consistency. The liner brush Boris uses has been trimmed down with a razor blade from a larger squirrel hair brush. It looks like a wet noodle.

Painting Borders

The border work in Zhostovo painting is stunning. The gorgeous combination of commas, dots, and linework produces exciting and elegant frames that compliment the beautiful florals.

Traditionally, Zhostovo borders are painted with gold metallic paint. Occasionally, they are painted with silver metallic paint. However, other pigments can be used, as well. Borders can also be created using bronzing powders and gold leaf.

I have had very good results using acrylic metallics to paint the borders. This paint dries quickly which helps me keep my hands out of the wet paint as I go around the surface, building the borders.

Painting S-strokes, C-strokes or teardrop strokes in combination will create the ornamentation or borders. Usually one kind of stroke is done around the entire border, then the next type of stroke is added to that row until you build the size border you want.

Painting a Rose

Роза любви

Most of the magnificent trays are painted using similar
design elements. Because the colors are brush-mixed
on the palette, the elements are never painted the same way
twice. You may notice slight variations in colors.
However, the concepts behind the painting and the process of
accomplishing it are the same.

We asked Boris to paint a simple, single rose to put in this
book. When he painted, we had beautiful music playing in
the background. We were all spellbound watching him. His
brush seemed to flow over the surface as this magnificent rose
began to appear. Tears ran down our faces as we watched the
magic of his brush. When he painted the leaves, we could not
believe our eyes as he filled in the highlights to look like
feathers of a bird. As you paint this beautiful rose, I hope
that you feel some of the magic that we felt that day!

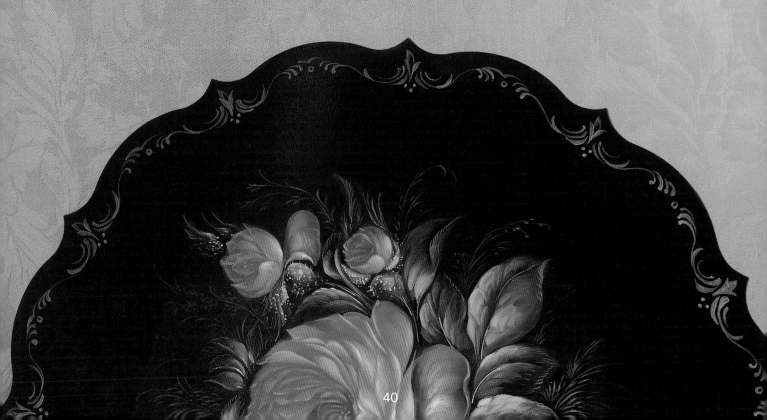

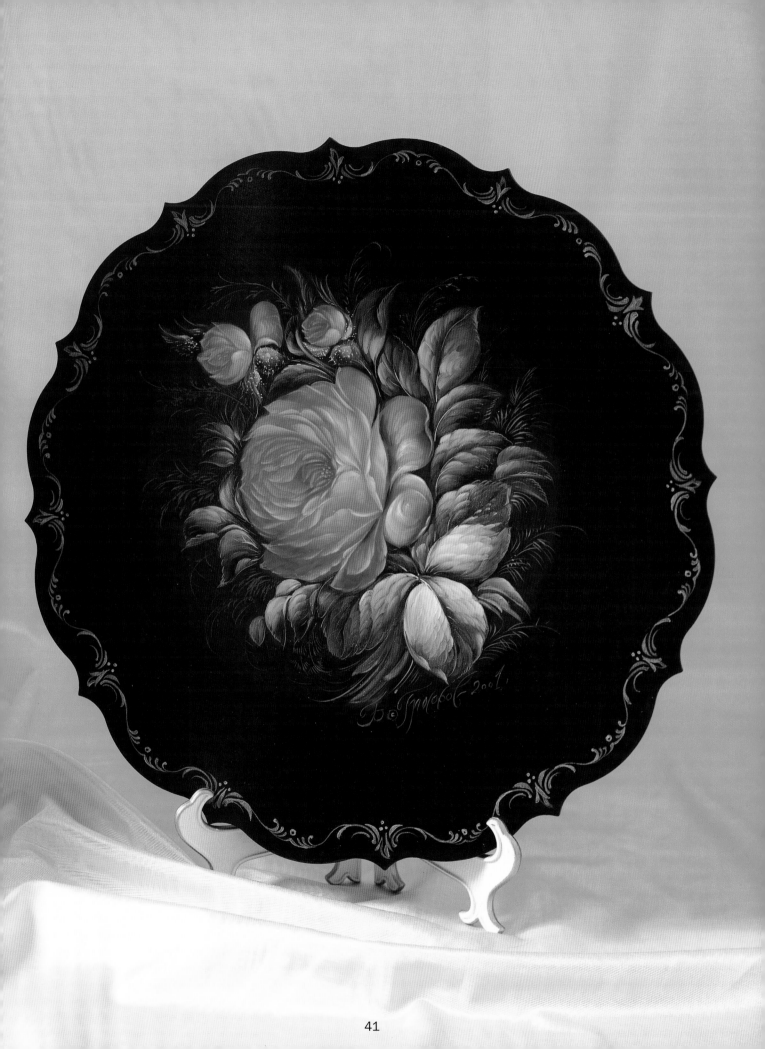

COLOR PALETTE

Asphaltum
Alizarin Crimson
Burnt Sienna
Cadmium Orange
Cadmium Red Deep
Cadmium Red Light
Cadmium Yellow Medium
Titanium White

OTHER SUPPLIES

Acrylic craft paint:
 White
Brush-on or Spray Paint:
 Flat black (for basecoating
 background)
Brushes:
 Small filberts (#2, #4 or #6)
 Medium filberts (#8 or #10)
 Large filberts (#12 or #14)
 Liner, #1, 1/0, or scroll brush
Mediums:
 Turpenoid
 Linseed Oil
Painting Surface:
 Large wooden plate

HERE'S HOW

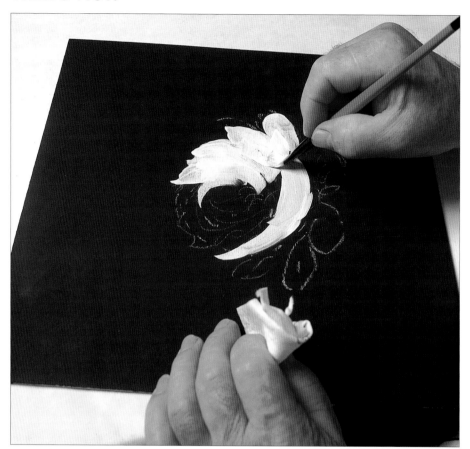

1. Undercoat entire transferred design with white acrylic paint, using the same strokes you will use to paint the design. Let dry. Scrape undercoating with a single edged razor blade, remove residue, and sand lightly with a brown paper bag. Apply a very thin layer of linseed oil to the undercoating.

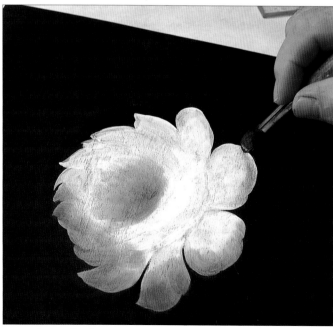

2. Lightly feather in Asphaltum + Cadmium Yellow Medium for first shading.

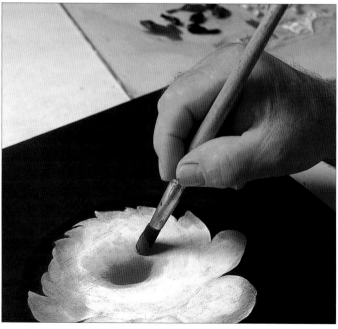

3. For second shading, apply Cadmium Red Deep on top of the yellow.

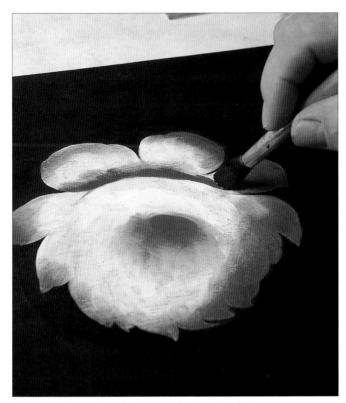

4. Shape lower bowl with Cadmium Red Deep.

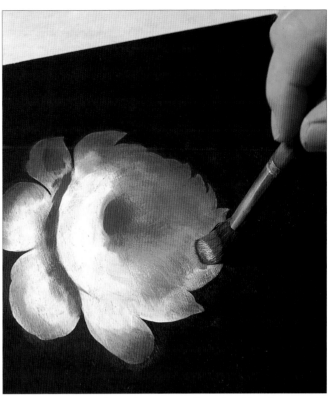

5. Fill in rose with Cadmium Red Light, blending in all colors.

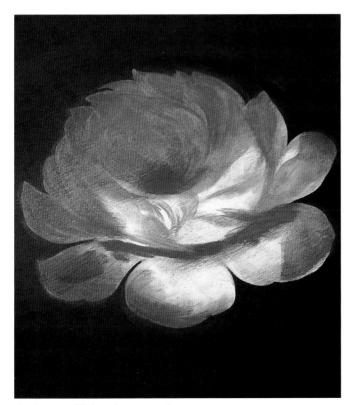

6. As you fill in, shape petals.

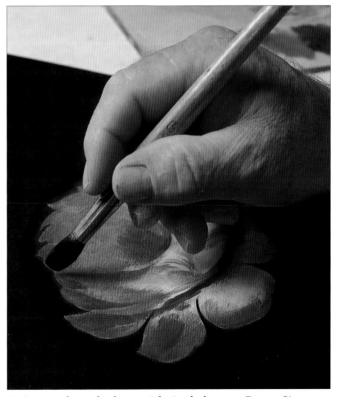

7. Lay in deep shadows with Asphaltum + Burnt Sienna + Cadmium Red Deep to form petals.

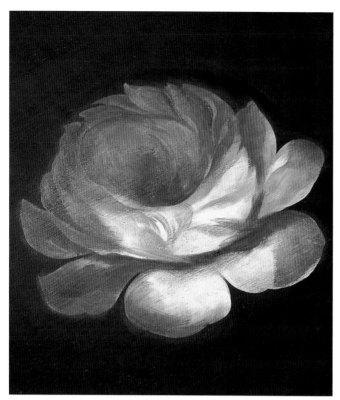

8. Shape back petals with the deep color.

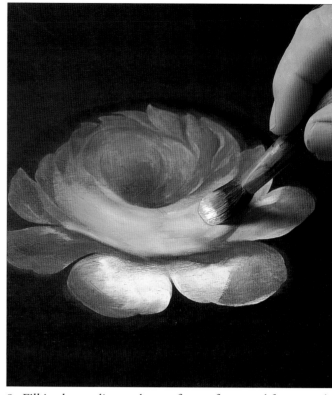

9. Fill in the medium value on front of rose and front petals with Titanium White + Cadmium Red Light. Blend as you go.

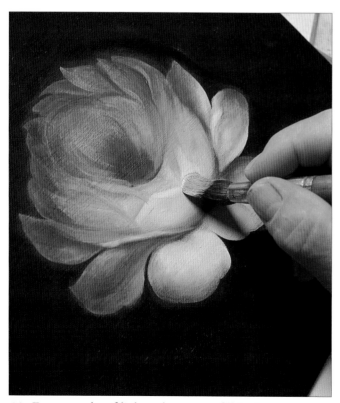

10. Form streaks of light color as you fill in the rose.

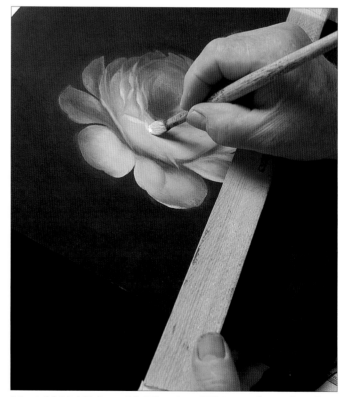

11. Add highlights with Titanium White to form the edges of petals. For back petals, form edges by adding highlights of Titanium White + Cadmium Red Light (a pink mix).

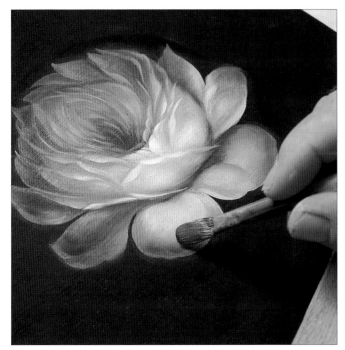

12. If needed, deepen shadow areas with Cadmium Red Deep. Also refine with light mixes, if needed.

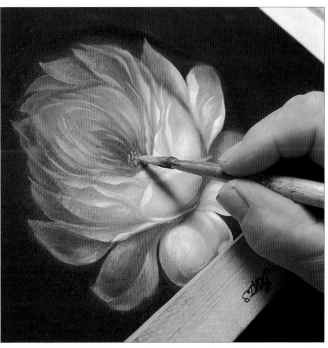

13. In center seed area of rose, make little dots with Titanium White + Cadmium Yellow Light.

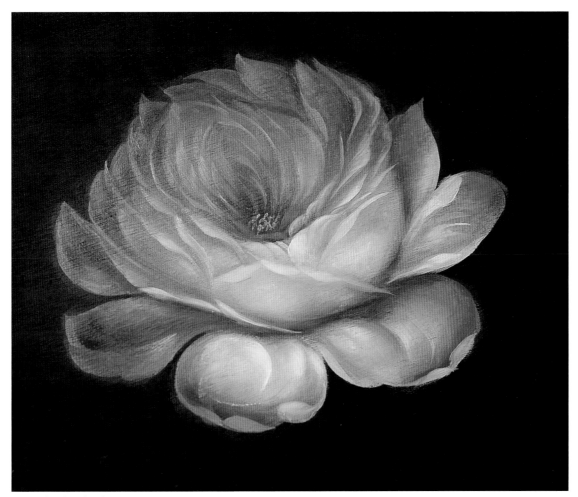

14. The finished rose.

Painting a Leaf

Zhostovo leaves will vary dramatically in color, but the actual technique of painting all of them is similar. Usually there will be a variation of warm and cool leaves in a design. This adds contrast and excitement within the design. The worksheet illustrates a medium value leaf and a fall colored leaf. Don't be afraid to experiment with color. Let your creativity be your guide! Study the leaves on the finished pieces in the book for inspiration.

Refer to the Leaf Painting Worksheet

REGULAR LEAF:

1. Undercoat the design with white acrylic paint. Let dry. Rub on a thin layer of linseed oil with a small cotton cloth.
2. Apply Alizarin Crimson to the tip.
3. Apply Cadmium Yellow Medium as shown and lightly blend.
4. Brush Prussian Blue over the yellow. Define a vein line with Prussian Blue. Apply a tiny touch of Prussian Blue to the tip as well as the base of the leaf.
5. Mix Prussian Blue + White (1:10 ratio) to make an ice blue color. Fill in the area near the stem with this mixture, using a variation of the S-stroke. With a very light touch, stroke over the rest of the leaf to softly blend the colors together.
6. Using White, stroke in highlights as shown. On one side of the tip stroke in a highlight in order to make a turn.
7. Fill an excellent liner brush with the thinned ice blue mix. Carefully paint the broken linework.

FALL LEAF:

1. Undercoat the design with white acrylic paint. Let dry. Rub on a thin layer of linseed oil with a small cotton cloth.
2. Shade the bottom tip and the area where the leaf joins the stem with Alizarin Crimson.
3. Apply Cadmium Yellow Medium to the upper one-third of the leaf, softly blending the color into the Alizarin Crimson.
4. Apply Sap Green on the tip and the vein.
5. Stroke in highlights and the turn with White, using variations of the S-stroke.
6. Mix a touch of Cadmium Yellow Medium with the White. Fill an excellent liner brush with the thinned mixture and carefully paint the broken linework.

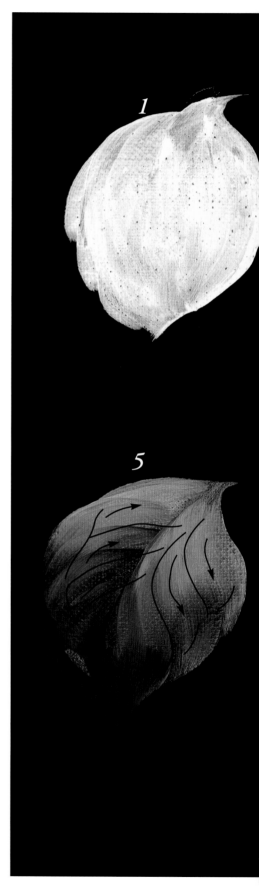

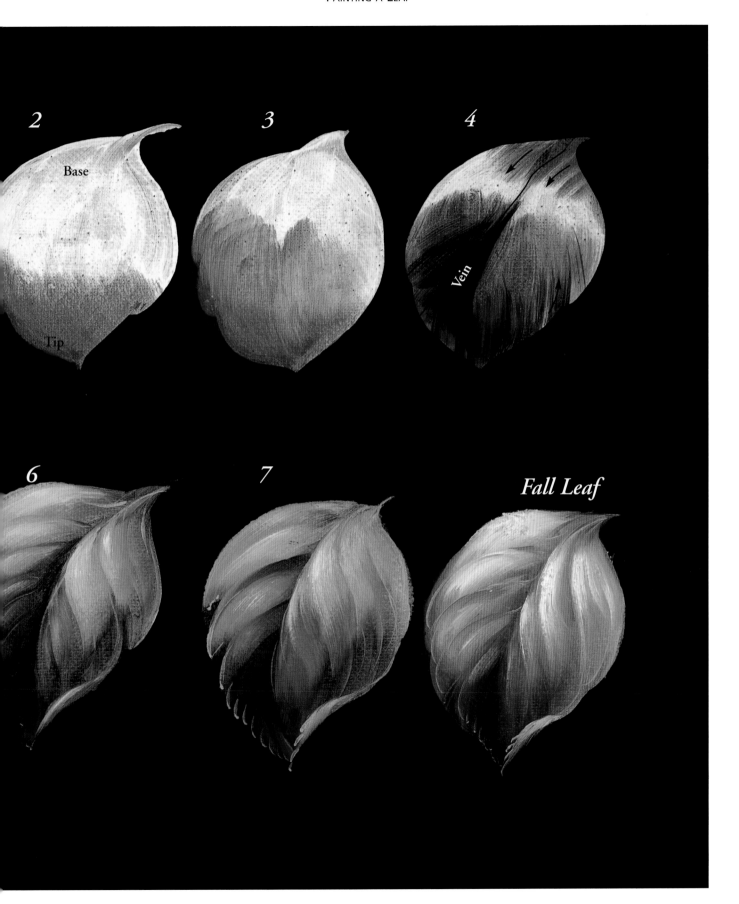

Painting a Rose & a Leaf WITH ACRYLICS

COLOR PALETTE

Craft Acrylic Paints:
The color names used here are acrylic artist pigments in a bottle. You can find the same colors, often with the same color names in many brands.
Alizarin Crimson
Burnt Carmine
Burnt Sienna
Ice Blue
Medium Yellow
Napthol Crimson
Red Light
Sap Green
True Burgundy
Warm White
Yellow Light
Wicker White (craft acrylic for undercoating)

OTHER SUPPLIES

Mediums:
　Glazing Medium
　Blending Medium
Brushes:
　Liner – size #1
　Filberts – sizes #6 and #8
Sta-Wet Palette

Authentically, the beautiful art of Zhostovo florals is done with oil paints. However, many of the techniques can be painted in acrylics. No, the look is not quite the same, but the overall effect can be lovely.

The following step-by-step instructions and painting worksheets will show you a Zhostovo leaf and rose created using artist's acrylics.

PAINTING INSTRUCTIONS

The Leaf

Refer to the Acrylic Rose & Leaf Painting Worksheet #1.

1. Neatly undercoat the leaves, preferably using brush strokes, with Wicker White. Apply the paint smoothly and evenly. Let dry. Apply a second coat for good, opaque coverage. Let dry and cure. (Illus #1)

2. Anchor the dark shadows as shown on the worksheet. Let dry. (Illus. #1)

3. Apply a thin coat of glazing medium to the leaf, then double load the brush with Sap Green and Burnt Sienna. Apply this at the base of the leaf. Pick up Sap Green and apply to the vein area. Apply Alizarin Crimson at the tip of the leaf. Lightly blend these colors into the glazing medium. Let dry. (Illus. #2)

4. Apply more glazing medium and reapply the same colors in the same places on the leaves. Wipe the brush and brush-mix more Sap Green and Ice Blue on the right side of the leaf. Stroke from the vein out into the wet color (as shown in illustration #3 on the worksheet).

5. On the other side of the leaf, stroke from the outside edge in toward the vein. Lift the brush as you stroke inward (like an airplane taking off) so you don't drag the strokes too far into the dark color. It is important to keep the paint wet. (Illus #3.) **Note:** If the paint dries before you finish, go ahead and let it dry thoroughly and cure. Reapply glazing medium or try a little blending gel. Reapply the shadow colors, then quickly apply the strokes of Sap Green and Ice Blue.

6. While the paint is still wet, wipe the brush and pick up a tiny bit of Warm White on one side of the brush. Lightly brush on the highlights. Let the paint dry. (Illus. #3)

7. Using an excellent liner brush full of very thin paint, outline the leaves. The leaves may be outlined in any color desired. I have used a mix of Ice Blue + Napthol Crimson. (Illus. #4) Also refer to the finished rose on Acrylic Rose & Leaf Painting Worksheet #1.

The Rose

Refer to the Acrylic Rose & Leaf Painting Worksheet #2.

1. Neatly undercoat the rose using brush strokes with Wicker White as shown on the worksheet. (Illus. #1) Let dry.
2. Double load a large brush with glazing medium and True Burgundy. Float this on the lower petals as shown on the worksheet. (Illus. #2)
3. Apply a thin coat of glazing medium to the upper portion of the rose. Apply a mix of True Burgundy + Burnt Carmine (1:1 ratio) to form shadows, as shown. (Illus. #2)
4. Apply Red Light to the top of the rose and the bowl of the rose as shown. Gently blend the dark color into the light color. (Illus. #2) Study this on the worksheet, but do not try to copy it exactly. It will be much easier if you don't, and you will paint a lovely rose. Remember, each one will turn out differently. Let dry.
5. Apply more glazing medium and repeat Steps 3 and 4. Let dry.
6. Apply more glazing medium to the rose. Using your #6 filbert brush, apply the dark mix of Burnt Carmine + True Burgundy to the lower petal. (Illus. #2)
7. Wipe the brush, pick up a generous amount of Red Light on the filbert, and stroke from the outside edge into the base.
8. Re-moisten with glazing medium, if needed. Apply the dark mix and a little Red Light to the upper portion of the rose. Create brush strokes coming from the outside edge of the flower, then toward the center.
9. To create the bowl (be sure the glazing medium is wet), double load the filbert brush with the dark mix and Red Light. Follow the strokes on the worksheet, keeping the Red Light on top and building the petals, stroke by stroke, over the front of the rose. (Illus. #2)
10. While the paint is still wet, pick up a little Warm White on the filbert brush and highlight here and there as shown on the worksheet. (Illus. #3)
11. Outlining: Outlining is a very important part of much of the Zhostovo style of painting. Fill your liner brush full of thinned Warm White. Study the color worksheet, but don't try to copy it. Apply the thin lines as accents on the lower upper petals and across the front of the flower. (Illus. #4) The leaves are also outlined as are the buds and calyx. The outlining seems to pull the whole design together. Remember when outlining, you should have an excellent liner brush, have your brush full of paint the consistency of ink, and hold the handle

of the brush so it points straight up toward the ceiling. Don't move the brush too quickly, but allow the paint time to flow from the hairs.
12. If desired, add fine lines of Yellow Light to the center of the rose. (Illus. #4)

The Stem & Calyx:

Refer to the Acrylic Rose & Leaf Painting Worksheet #2.

1. Apply a tiny bit of glazing medium to the stem and calyx. Paint them Sap Green. (Illus. #2)
2. Shade while wet with Burnt Sienna. (Illus. #2)
3. Highlight with Warm White. (Illus. #3) Let dry.
4. Fill the liner brush with Warm White. Paint the linework on the stems and calyx as illustrated on the worksheet. (Illus. #4)

The Bud:

Refer to the Acrylic Rose & Leaf Painting Worksheet #2.

1. Neatly undercoat the bud as shown on the worksheet with Wicker White. (Illus. #1) Let dry.
2. Using a small brush, apply a mix of True Burgundy + a touch of Burnt Carmine to the shadow areas as shown on the worksheet. (Illus. #2.) Let dry.
3. Apply glazing medium to the areas of the bud. Complete one area at a time.
4. Apply Red Light and more of the dark mix and blend. (Illus. #3) Let dry. Repeat this step. Let dry.
5. Using the liner brush and thinned Warm White, outline as shown on the worksheet. (Illus. #4)

The Grass:

The term "grass" means the wonderful and graceful fill-in strokes used around the rose and the leaves. In the finished painting, the grass is created with a mix of Red Light + Burnt Sienna (1:1 ratio). The green is a mix of equal amounts of Sap Green + Medium Yellow. Refer to "Linework Filler Ornamentation Painting Worksheet" in Stroke Linework & Ornamentation Section. Fill the liner brush full of thinned color. Practice the very fine linework, then add it to your painting. It should be loose, flowing, and airy.

Finish:

Remember, acrylics dry very flat. It is important to varnish your painting..

1. Let the paint dry and cure.
2. Apply several coats of a good high gloss, water base varnish. ❑

Rose

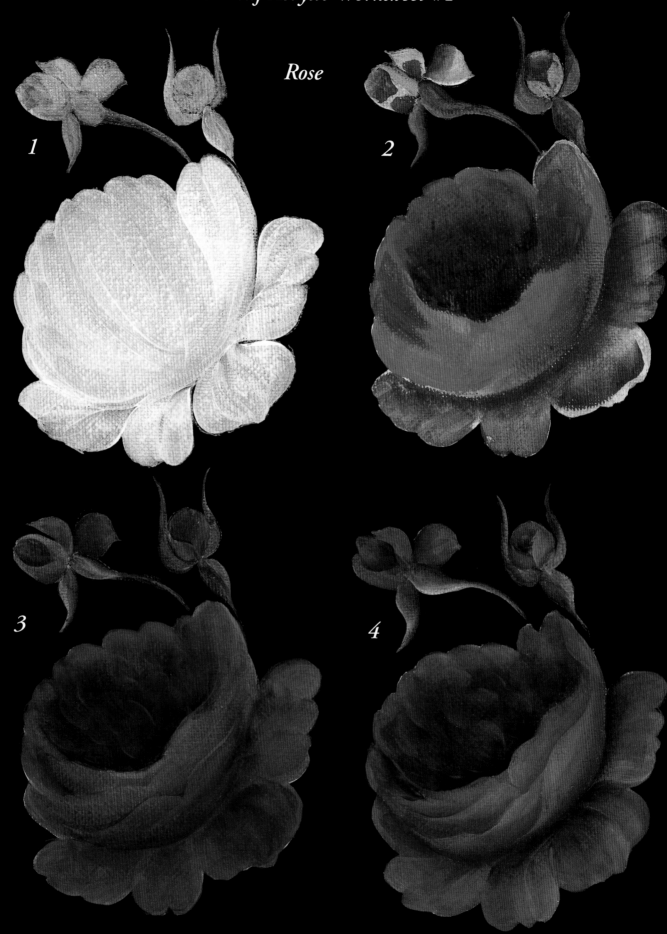

1

2

3

4

Leaf

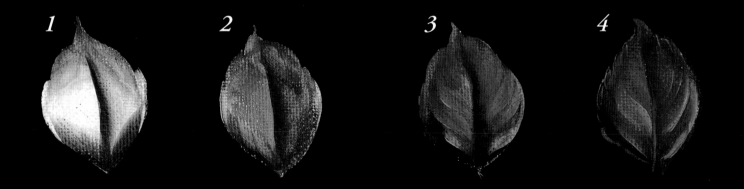

1 2 3 4

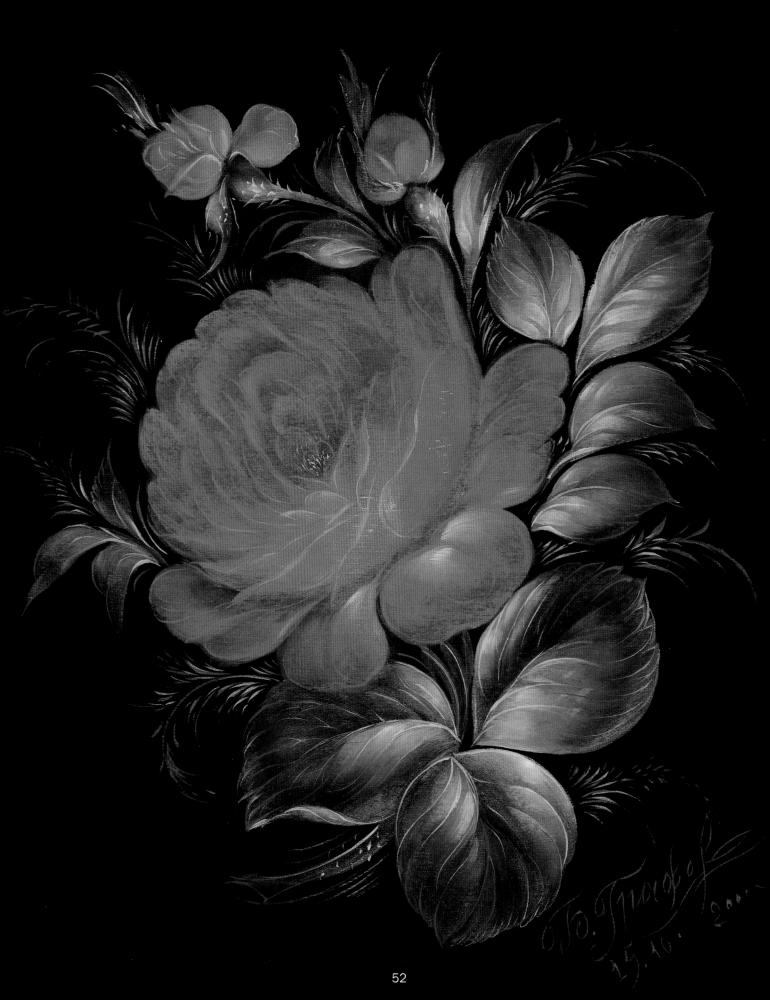

Pattern for a Single Red Rose
(actual size)

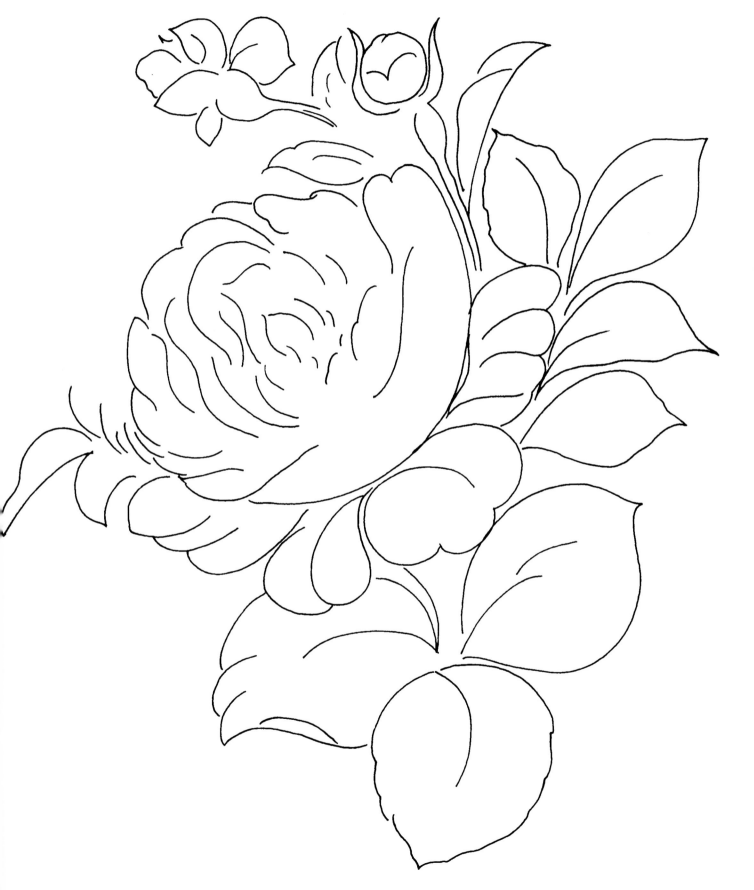

A Painting
STEP-BY-STEP

Now that you know how to paint a rose and leaves, you can combine these elements in a design. Bunch three roses together, fill out the bouquet with some blossoms flowers, enhance the design with some graceful linework "grasses," and embellish your project with a metallic border or trim. There you have it — an authentic Russian folk art painting.

Follow the process with photographs on the following pages.

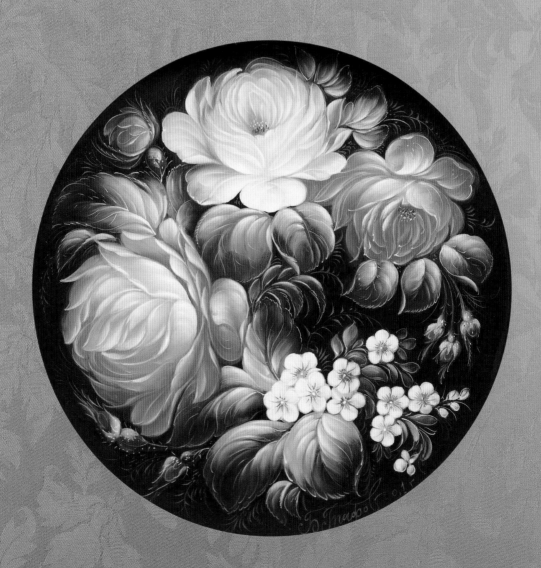

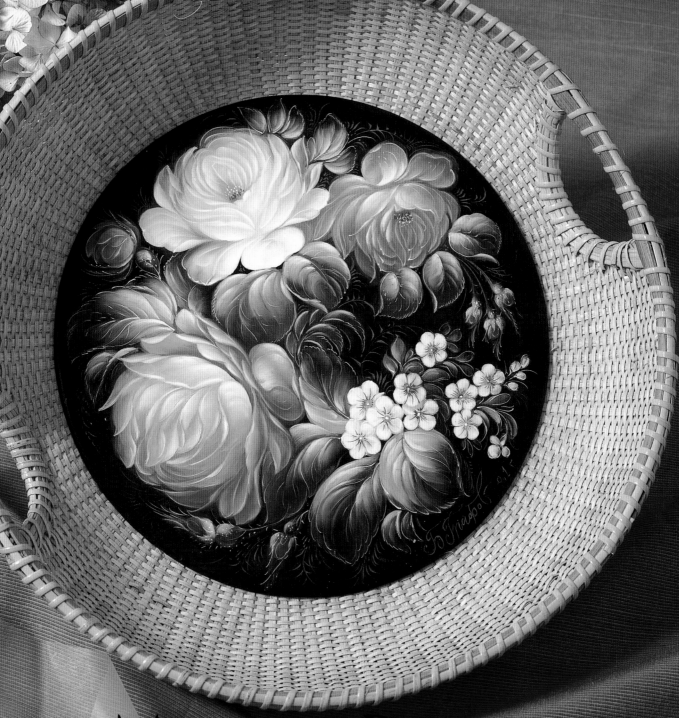

MORNING ROSES

Утренние розы

Morning Roses Basket

Color Palette

Alizarin Crimson
Asphaltum
Burnt Sienna
Cadmium Orange
Cadmium Red Light
Cadmium Red Deep
Cadmium Yellow Deep
Cadmium Yellow Light
Cadmium Yellow Medium
Prussian Blue
Sap Green
Viridian
White

Other Supplies

Acrylic Craft Paint:
 Wicker White
 Black
Brushes:
 Small (#2, #4, or #6)
 Medium (#8 or #10)
 Large (#12 or #14)
 Liners (#1 + 10/0 or scroll)
Mediums:
 Turpenoid
 Linseed Oil
Painting Surface:
 Wicker basket with
 wooden bottom inset
Fine steel wool

Project Instructions

Preparation:

1. Basecoat the bottom of the basket by brushing on two or three coats of flat Black paint.
2. Let the paint dry and sand in between coats with very soft steel wool. Wipe all of the residue off with a tack cloth.
3. Sand after the last coat with a crumpled piece of brown paper bag. Wipe with a tack cloth.
4. Seal with matte acrylic spray. Let dry. Rub lightly with the brown bag. wipe all of the residue off with the tack cloth.
5. Neatly trace and transfer the design, using colored chalk.

Flowers:

See the step by step photos and instructions that follow for painting the leaves, the coral roses, the blossoms and the line work.

White Rose:

1. Brush Asphaltum around the outer edges of the rose and in the center.
2. Brush Alizarin Crimson into the center.
3. Brush the large petals on the left of the rose with Cadmium Orange.
4. Brush Sap Green over the outer edges of the rose and around the center, softly blending where the colors meet. Do not bring the Sap Green onto the front of the bowl.
5. Brush mix Sap Green and White and form the petals around the rose.
6. Add more White and form the highlights on the petals on the front bowl. This is the lightest portion of the rose.

Here's How:

Step 1: Chalk the outline of the design on the backside of the traced pattern.

Step 2: Turn the design over onto the painting surface. Trace the design with a pencil or stylus.

Step 3: Undercoat the design with white acrylic paint, using the same strokes that you will use to paint the design.

Step 4: Complete the design with the undercoat.

Step 5: Use a single edged razor blade to scrape the entire design. (Hold the razor blade straight up to keep it from gouging the surface.)

Step 3

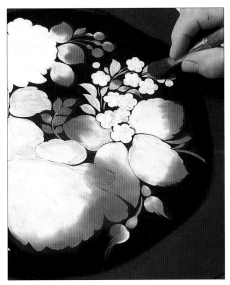

Step 9

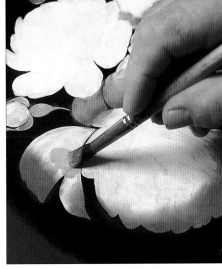

Step 10

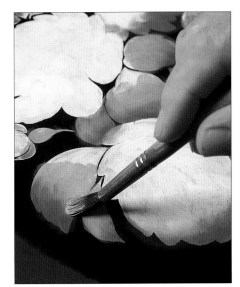

Step 11

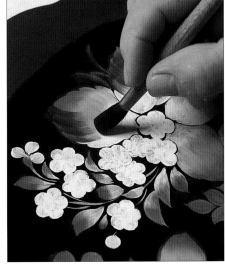

Step 12

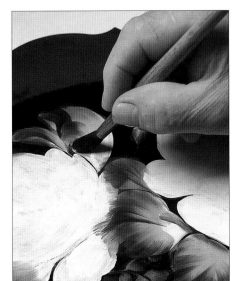

Step 13

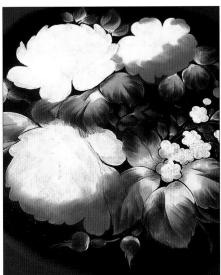

Step 13

Step 6: Sand lightly with a piece of brown paper bag.

Step 7: Apply a very thin layer of linseed oil to the design with a small piece of cotton cloth.

Step 8: Condition the brush with linseed oil. Touch the end into Alizarin Crimson. Blend the color into the brush by brushing back and forth on the glass palette.

Step 9: Brush Alizarin Crimson onto the leaf tips, the buds, and the edges of the petals of the two coral colored roses. Photos shows the completed first shadows.

Step 10: Apply Cadmium Yellow Deep to the centers of the leaves.

Step 11: Blend softly where the two colors meet.

Step 12: Brush-mix Sap Green + Viridian. Brush over leaves, allowing some of the colors to show through.

Step 13: Define the veins down the center of the leaves with the Sap Green/Viridian mix. The leaves are now two-thirds painted.

continued on page 58

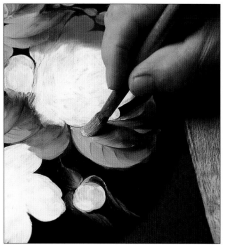

Step 14: Brush-mix Prussian Blue + White to make a medium value ice blue. Load the brush with this mixture. Brush the ice blue mix on the leaves to fill in the top one-third of the leaves.

Step 15: Add more White to the ice blue mix to make an ice blue light mix.

Step 16: Using a variation of the S-stroke, pull the ice blue light mix in the lightest area of the leaves.

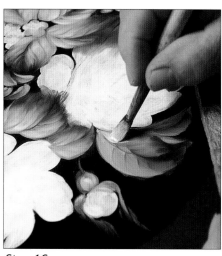

Step 14

Step 16

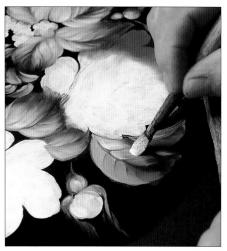

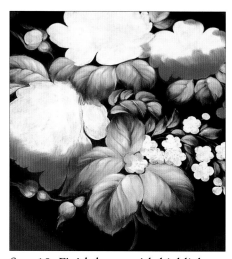

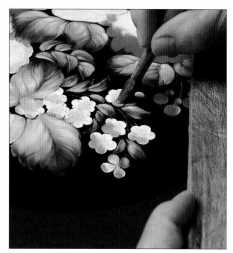

Step 17: Brush on White highlights.

Step 18: Finish leaves with highlights.

Step 19: Paint the center of the small blossoms with Cadmium Yellow Light. (See Small Blossom Painting Worksheet.)

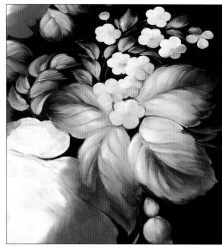

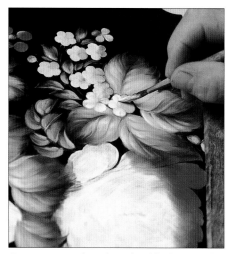

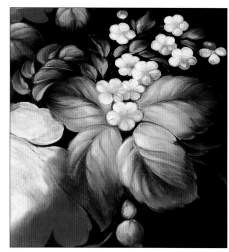

Step 20: Brush Sap Green around the center of each small blossom. Brush the ice blue mix on the left side of each blossom.

Step 21: Brush White highlights on the blossoms.

This photo shows finished small blossoms.

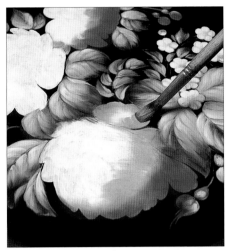

Step 22: Brush Cadmium Orange onto the large closed rose.

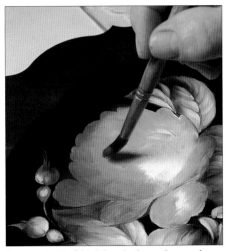

Step 23: Softly blend the edges where the Alizarin Crimson and Cadmium Orange meet.

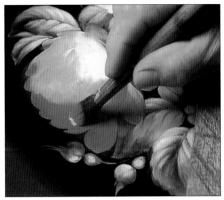

Step 24: Brush on Cadmium Red Deep to form the petals on the shadow side of the large rose and around the outer edges of smaller rose.

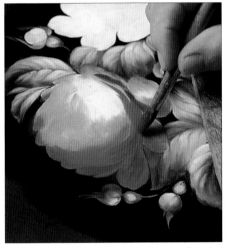

Step 25: Stroke in Burnt Sienna for the deep shadows.

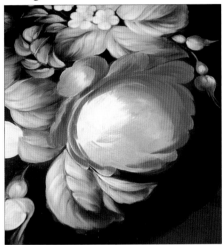

Complete laying in of the shadows.

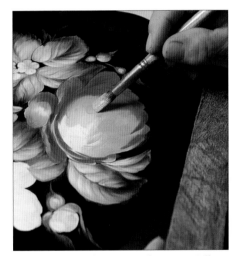

Step 26: Brush on Cadmium Yellow Light to form the bowl of the rose. Softly blend where the colors meet.

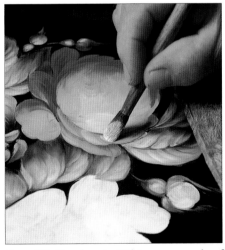

Step 27: Brush-mix White + a touch of Cadmium Yellow Light. Form the petals on the bowl of the rose.

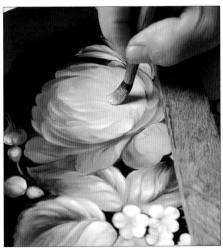

Step 28: Add a little more White. Form the edges of the petals

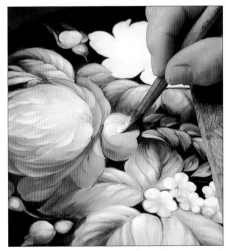

Step 29: Mix a touch of Cadmium Red Light + White to form the petals of the smaller rose and the buds.

Step 30: Add more White to the dirty brush and paint the highlights on the lower petals. Paint the petals on the front of the bowl of the smaller rose and the front of the buds with White.

Step 31: Make a few dots of Burnt Sienna in the center of the small rose.

Step 32: Mix a touch of White + the ice blue mix. Thin the mix with linseed oil and turpenoid (a 1:1:1 ratio) to a thin flowing consistency. Fully load the liner brush.

Step 33: Paint the stems of the small blossoms and the broken linework around the leaves.

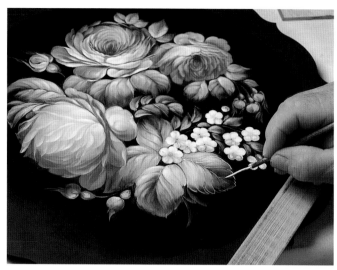

Step 34: Paint the veins in the leaves.

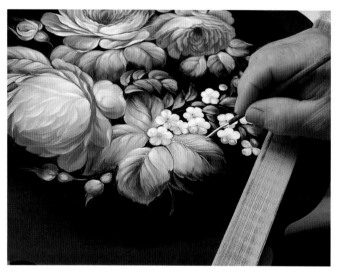

Step 33

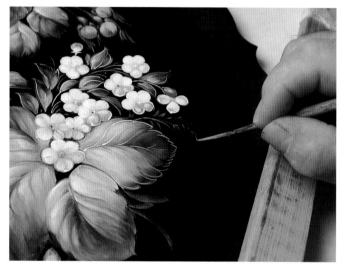

Step 35: Continue using the ice blue mix and paint the linework around the design. ❑

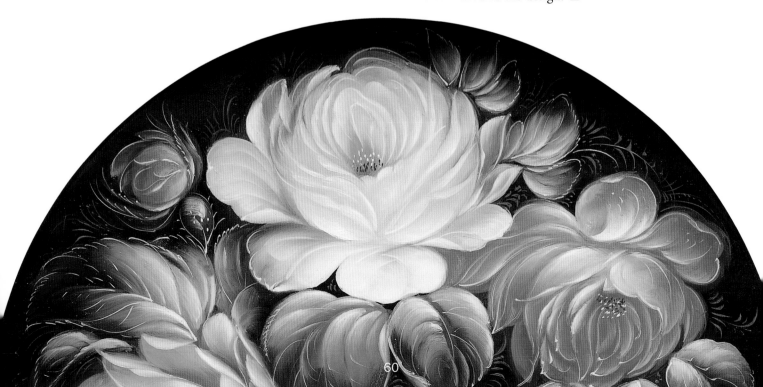

Pattern for Morning Roses Basket

Enlarge pattern @135% for actual size.

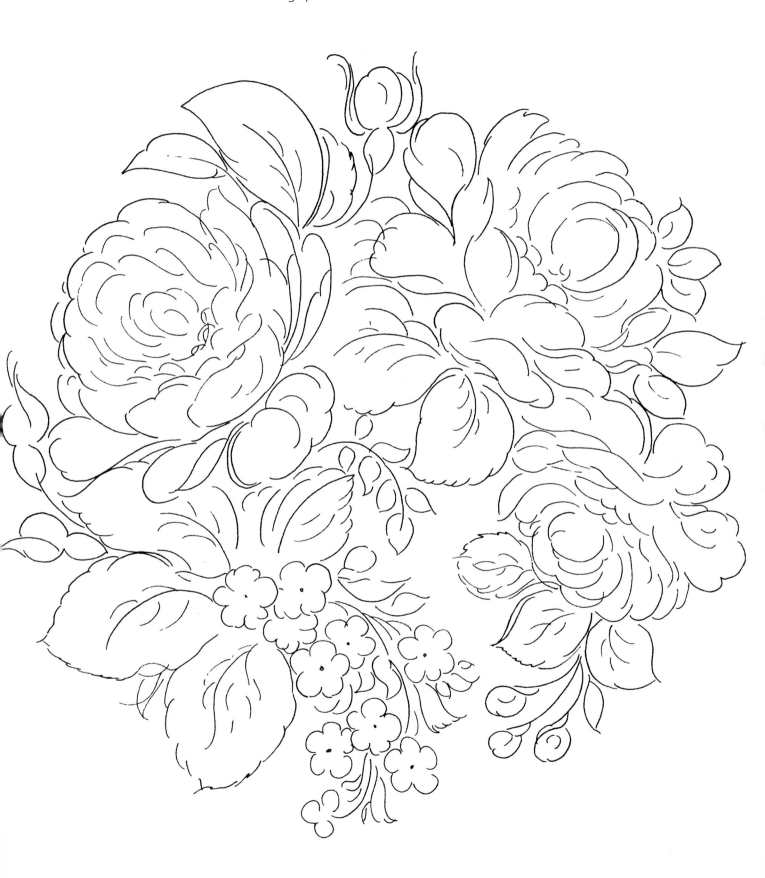

Russian Folk Art Project Lessons

Now that you have learned all the basics, you can move on to trying yor hand at painting some designs. You will find a variety of projects — from easy to more complex. The Blossoms Oval Tray would be a good project to start with because it requires you learn only one type of flower. We hope you will find learning this new art exciting and enjoy bringing the beauty of Zhostovo to your home.

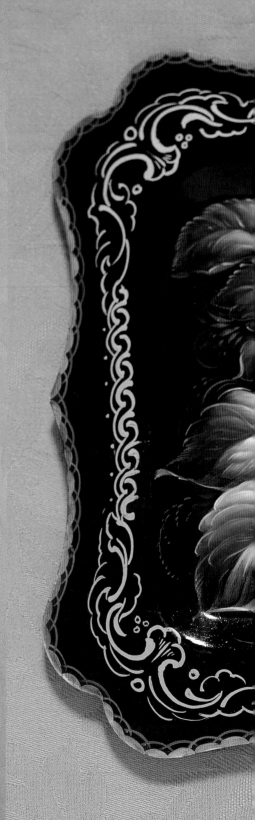

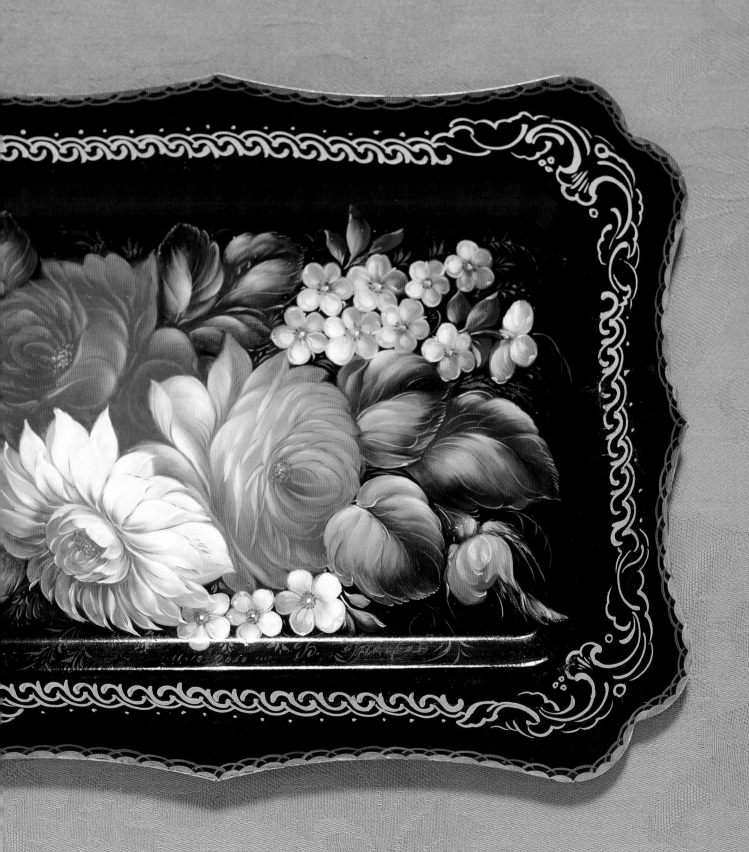

EVENING BLOSSOMS

Вечерний шиповник

The blossom flower can be painted in a variety of colors and in many different sizes. Blossoms are often used to fill out a bouquet design, but can also be the main flower. This project features the blossoms in a pretty pink. As the main flower, they are larger than those painted as filler flowers.

From the collection of Naomi Meeks

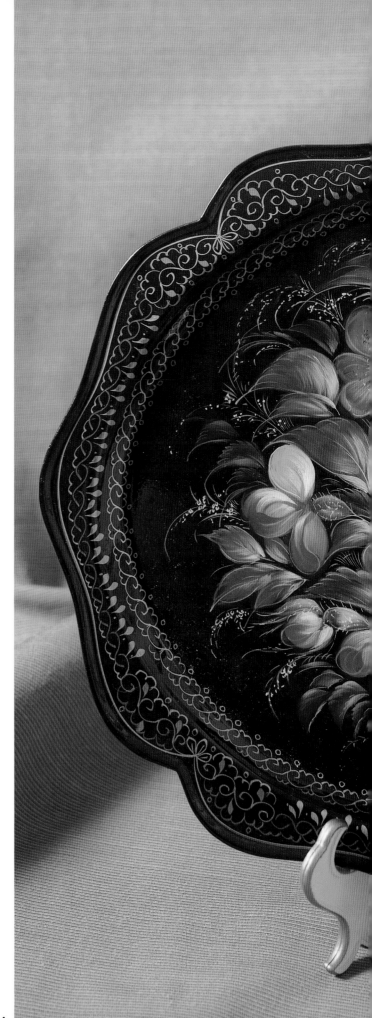

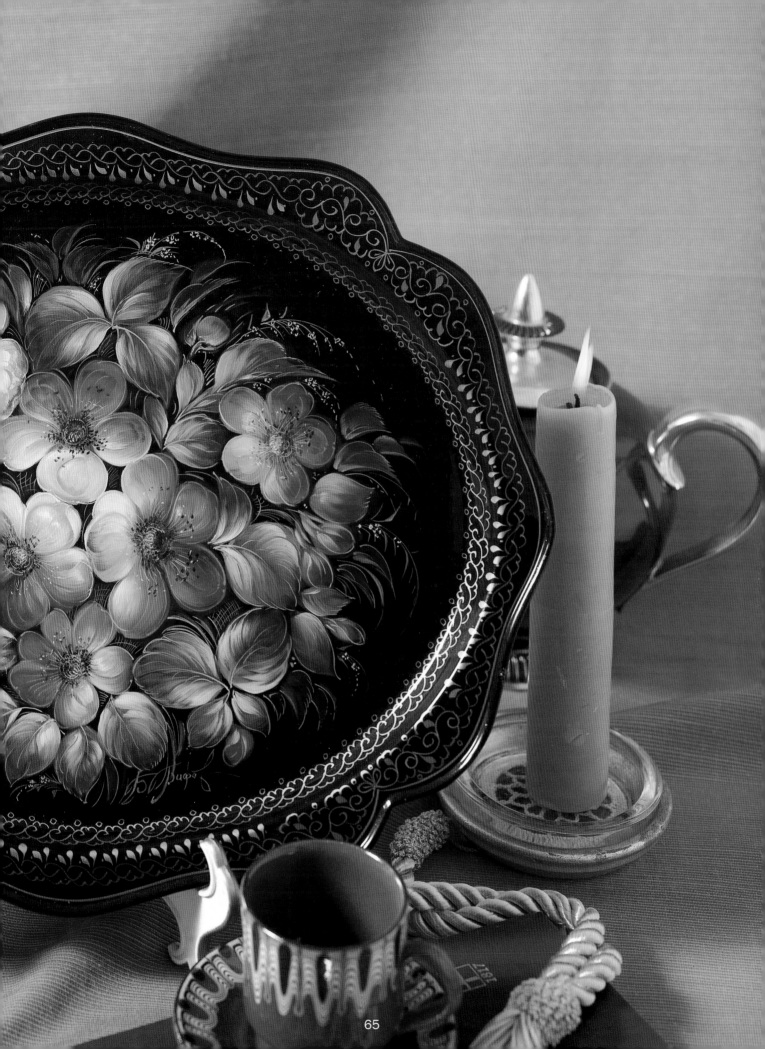

Evening Blossoms OVAL TRAY

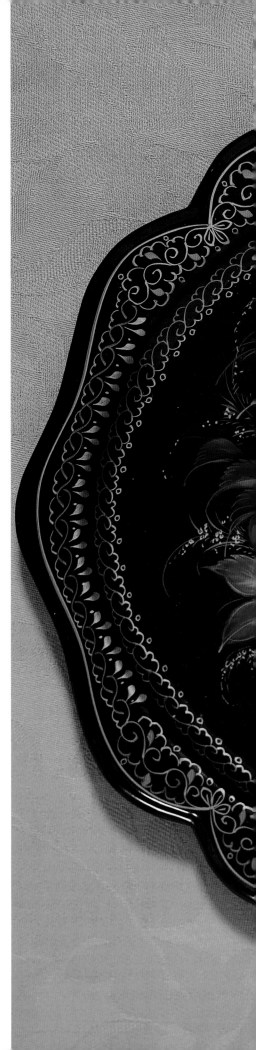

COLOR PALETTE

Alizarin Crimson
Asphaltum
Burnt Sienna
Cadmium Orange
Cadmium Red Deep
Cadmium Red Medium
Cadmium Yellow Light
Cadmium Yellow Medium
Sap Green
Viridian
White
Metallic Gold

OTHER SUPPLIES

Acrylic Craft Paints:
 White
Brush-on or Spray Paint:
 Flat black
Brushes:
 Small (#2, #4, or #6)
 Medium (#8 or #10)
 Large (#12 or #14)
 Liner, #1, 1/0, or scroll brush
Mediums:
 Turpenoid
 Linseed Oil
Painting Surface:
 Oval metal tray

PROJECT INSTRUCTIONS

Preparation:

1. Basecoat the tray by brushing or spraying on two or three coats of flat black paint. Let the paint dry and sand after each coat with very soft steel wool. Sand after the last coat with a crumpled piece of brown paper bag with no printing on it. Wipe with a tack cloth.

2. Seal with matte acrylic spray. Let dry. Rub lightly again with the brown bag. Wipe all of the residue off with the tack cloth.

3. Neatly transfer the design, using chalk.

Undercoating:

1. Undercoat the entire design with white acrylic paint. Let dry.

2. Scrape over only the design with a razor blade. Wipe off the residue.

3. Rub on a thin layer of linseed oil.

Leaves:

Refer to Leaf Painting Worksheet.

1. Paint the tips with Alizarin Crimson.

2. Apply Cadmium Yellow Medium and blend lightly where the colors meet.

3. Brush over the Cadmium Yellow Medium with Sap Green.

4. Define the vein with Alizarin Crimson.

5. Mix a touch of White + Sap Green or Viridian. Fill in the area near the stem with this mixture, using an S-stroke.
With a feather touch, stroke over the leaf to softly blend the colors together.

6. Brush on white highlights in the lightest areas.

7. Fill an excellent liner brush with a thinned mixture of White + a touch of the leaf color and carefully paint the broken linework on and around the leaf.

Blossoms:

Refer to the Pink Blossom Painting Worksheet. Colors vary slightly from worksheet.

1. Apply Asphaltum in the center, brushing it slightly outward onto the petals.

Continued on page 68

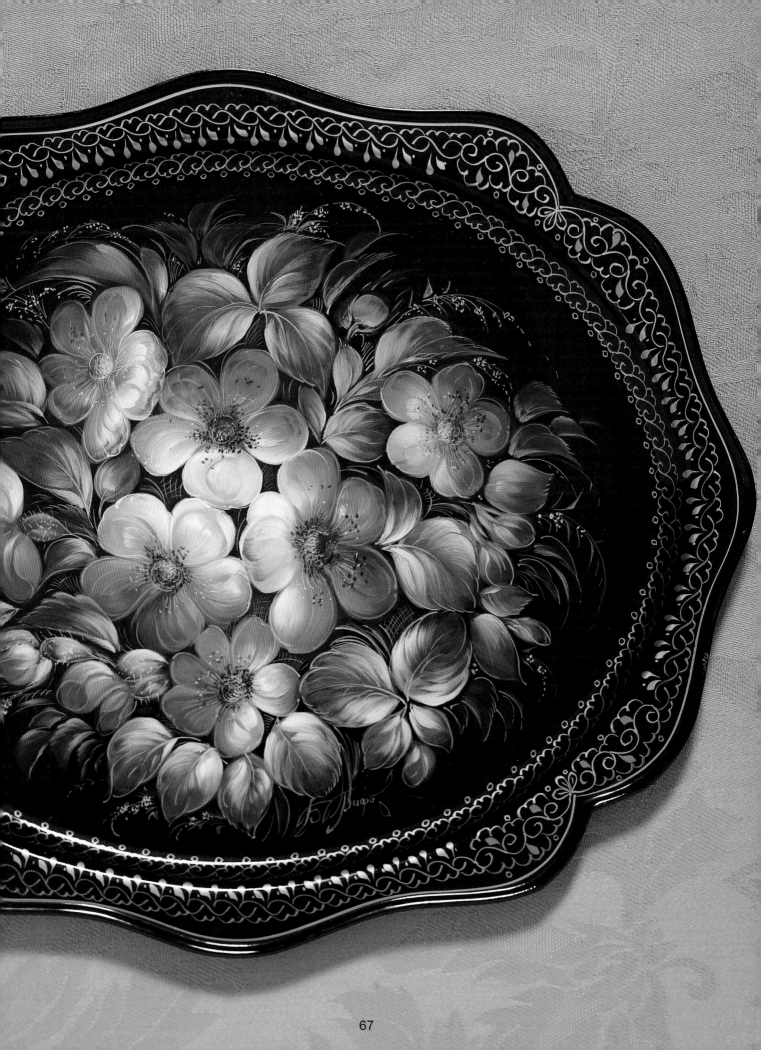

continued from page 66

2. Mix Cadmium Red Medium + Cadmium Red Deep (a 1:2 ratio). Softly brush the paint over the four flower petals.

3. Apply Alizarin Crimson to the shadow side of the flower.

4. Mix Cadmium Red Deep + Cadmium Orange. Overstroke the shadow side of the petals. Mix Cadmium Red Deep + Burnt Sienna (a 1:1 ratio). Shade around the center and onto the lower petals.

5. Mix White + Cadmium Yellow Light (a 1:1 ratio). Overstroke the light petals first. Do not pick up more paint but overstroke the other petals very lightly.

6. Thin White with a drop of turpenoid. Overstroke highlights on each petal with comma strokes, starting with the lightest petals.

7. Thin White with turpenoid and linseed oil (a 1:1:1 ratio). Fill the liner brush with the mixture and paint linework around each petal.

8. Paint the center with Alizarin Crimson. Make dots on each petal with Alizarin Crimson. Make a C-stroke in the center with Cadmium Yellow Light. Make dots on the petals with White. Mix Cadmium Yellow Light + White (a 1:1 ratio) and pull strokes from the center onto the petals.

Linework:

1. Mix a touch Cadmium Yellow Light + White. Thin the mixture with turpenoid and linseed oil to a flowing consistency. Paint the linework near the center of each blossom.

2. Mix your leaf color + Cadmium Yellow Light + and turpenoid and linseed oil to a flowing consistency. Complete the grass-like linework around the design.

Border or Ornamentation:

1. Fill an excellent liner brush with Metallic Gold thinned to a flowing consistency with linseed oil and turpenoid.

2. Choose a design that you like from the "Painting Borders" section and paint it around the tray. ❑

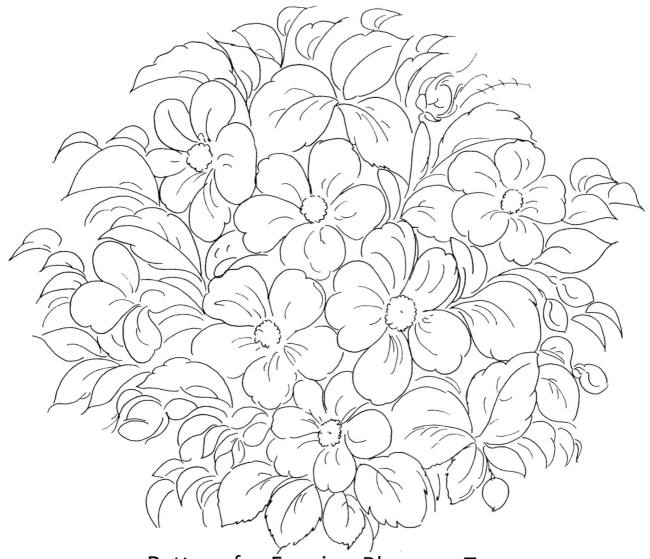

Pattern for Evening Blossoms Tray

Enlarge pattern @155% for actual size.

Pink Blossom Painting Worksheet

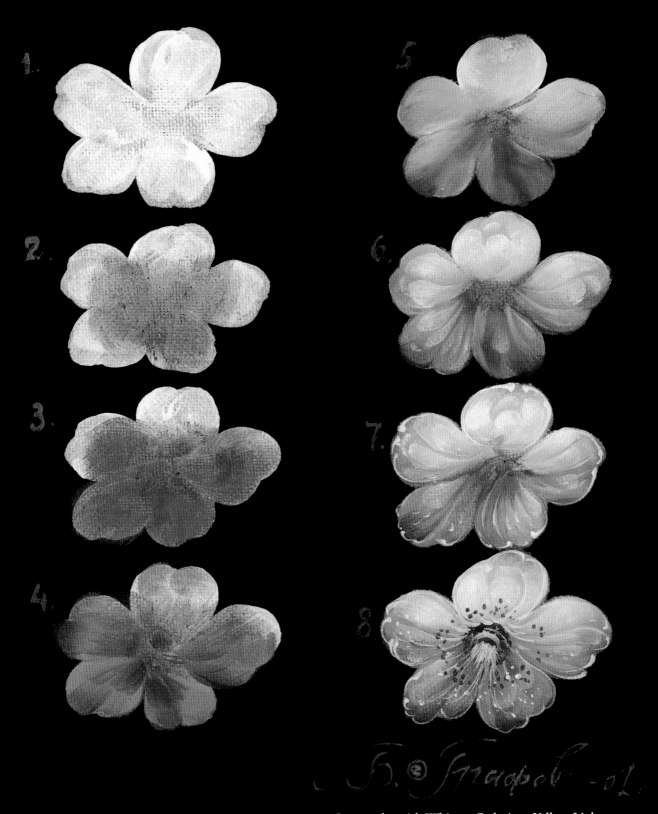

1. Undercoat with White.
2. Apply Asphaltum.
3. Softly brush Cadmium Red Light and Cadmium Orange over petals.
4. Overstroke with Cadmium Red Light + White. Shade around lower petals with Cadmium Red Deep + Burnt Umber + Burnt Sienna.

5. Overstroke with White + Cadmium Yellow Light.
6. Overstroke with thinned White.
7. Paint linework.
8. Paint center Alizarin Crimson. Make dots on each petal with Alizarin Crimson and White. C-Stroke in center Cadmium Yellow Light. Pull strokes of Cadmium Yellow Light + White from center onto petals.

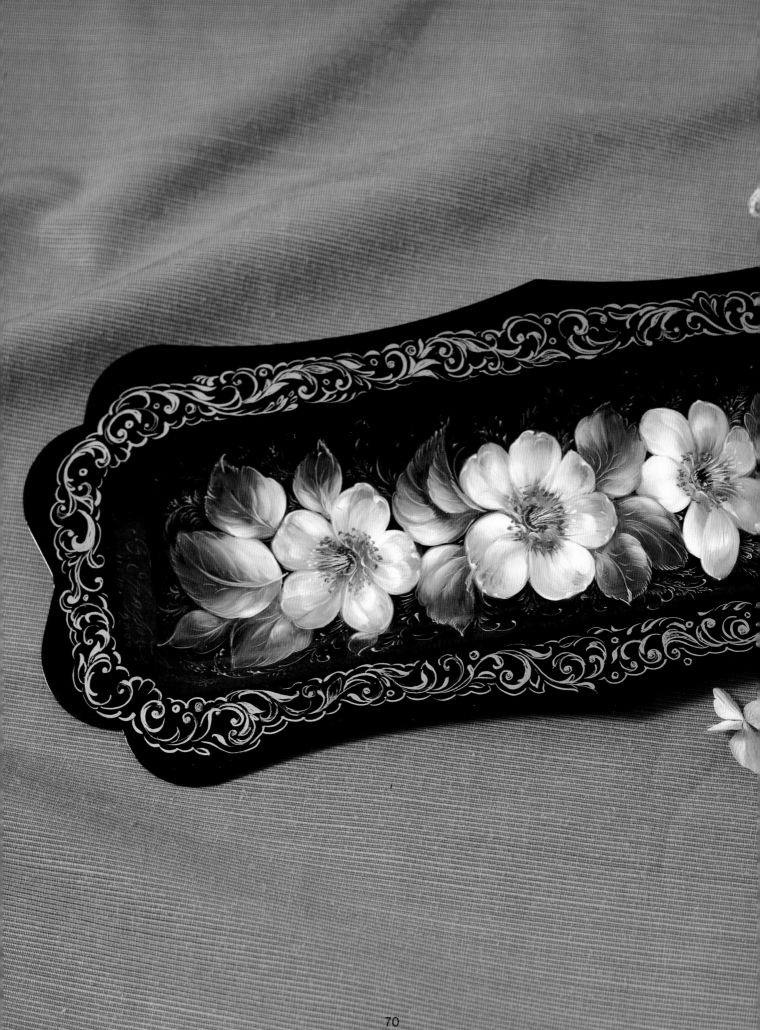

APPLE BLOSSOMS

Цветы яблони

This tray shows the blossom flower in a different color. Because the project is fairly small, the smaller size blossoms are used, even though it is the main flower of the design.

Apple Blossoms CRACKER TRAY

COLOR PALETTE

Alizarin Crimson
Asphaltum
Burnt Sienna
Burnt Umber
Cadmium Orange
Cadmium Red Deep
Cadmium Red Light
Cadmium Yellow Light
Cadmium Yellow Medium
Prussian Blue
Sap Green
Viridian
White
Metallic Gold

OTHER SUPPLIES

Acrylic Craft Paints:
 White
Brush-on or Spray Paint:
 Flat black
Brushes:
 Small (#2, #4, or #6)
 Medium (#8 or #10)
 Large (#12 or #14)
 Liner, #1, 1/0, or scroll brush
Mediums:
 Turpenoid
 Linseed Oil
Painting Surface:
 Small metal cracker tray
Fine steel wool

PROJECT INSTRUCTIONS

Preparation

1. Basecoat the tray by brushing or spraying on two or three coats of flat black paint. Let the paint dry and sand after each coat with very soft steel wool. Sand after the last coat with a crumpled piece of brown paper bag with no printing on it. Wipe with a tack cloth.
2. Seal with matte acrylic spray. Let dry. Rub lightly again with the brown bag. Wipe all of the residue off with the tack cloth.
3. Neatly transfer the design, using chalk.

Undercoating:

1. Undercoat the entire design with white acrylic paint. Let dry.
2. Scrape over only the design with a razor blade. Wipe off the residue.
3. Rub on a thin layer of linseed oil.

Cool Leaves:

NOTES: Refer to Leaf Painting Worksheet, using colors given here. Choose several of the leaves to be cool colored; the rest will be warm colored.

1. Paint the tips with Viridian.
2. Apply Cadmium Yellow Medium as shown on the worksheet and blend lightly where the colors meet.
3. Brush over the Cadmium Yellow Medium with Asphaltum, bringing it into the base of the leaf.
4. Define the vein with Alizarin Crimson. Apply a few strokes on the tip, pulling toward the vein.
5. Mix a touch of White + Asphaltum. Fill in the area near the stem with this mixture, using an S-stroke. With a feather touch, stroke over the leaf to softly blend the colors together.
6. Using White, stroke highlights as shown on worksheet.
7. Fill an excellent liner brush with Cadmium Yellow Light and carefully paint the broken linework around the leaf.

Warm Leaves:

Refer to Leaf Painting Worksheet, using colors given here.

1. Paint the tips with Sap Green.
2. Apply Cadmium Yellow Medium as shown on the worksheet and lightly blend where the two colors meet.
3. Brush over the yellow with Sap Green. Define a vein with Prussian Blue.
4. Apply Asphaltum to the base of the leaf and softly brush over the rest of the leaf to blend the colors.
5. Brush over the vein with Alizarin Crimson. Make several strokes on the tip with Alizarin Crimson.
6. Mix Cadmium Red Light + White (a 3:1 ratio), and add a touch of Cadmium Orange. Fill in the area near the stem with this mix.
7. Using White, stroke in highlights as shown on the worksheet.

8. Fill an excellent liner with Cadmium Yellow Light and paint the broken linework around the leaves.

Blossoms:

Refer to Pink Blossom Painting Worksheet.

1. Undercoat the design with wicker white acrylic. Let dry. Rub on a thin layer of linseed oil with a small cotton cloth.
2. Apply Asphaltum in the center brushing it slightly outward onto the petals.
3. Mix Cadmium Red Light and Cadmium Orange (1:2 ratio). Softly brush the paint over the four lower petals.
4. Mix White and Cadmium Red Light (3:1 ratio). Overstroke the lower petals and the outer edge of the top petal. Mix Cadmium Red Deep and Burnt Umber and Burnt Sienna (1:1:1 ratio). Shade around the center and onto the lower petals.
5. Mix White and Prussian Blue (10:1 ratio), to make an Ice Blue mixture. Overstroke the top petal first. Do not pick up more paint but overstroke the other petals very lightly.
6. Thin White with a drop of turpentine. Overstroke highlights on each petal with comma strokes starting with the top petal first.
7. Thin White with turpentine and linseed oil (1:1:1 ratio). Fill the liner brush with the mixture and do line work around each petal.
8. Paint the center with Alizarin Crimson. Make dots on each petal with Alizarin Crimson. Make a c-stroke in the center with Cadmium Yellow Light. Make dots on the petals with White. Mix Cadmium Yellow Light and White (1:1 ratio), pull strokes from the center onto the petals.

Linework:

Mix Cadmium Yellow Light + turpenoid + linseed oil to a flowing consistency. Complete the grass-like linework around the design.

Border or Ornamentation:

1. Fill an excellent liner brush with Metallic Gold thinned to a flowing consistency with linseed oil and turpenoid.
2. Paint the lacy looking border around the entire tray. If you will freehand this border, it will have a looser, more flowing appearance. Remember, it does not have to be perfect! The looser it is, the more beautiful it becomes! Allow yourself to create! ❏

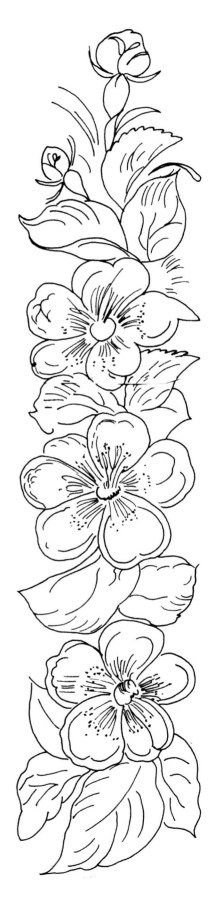

Pattern for Apple Blossom Cracker Tray

Enlarge pattern @135% for actual size.

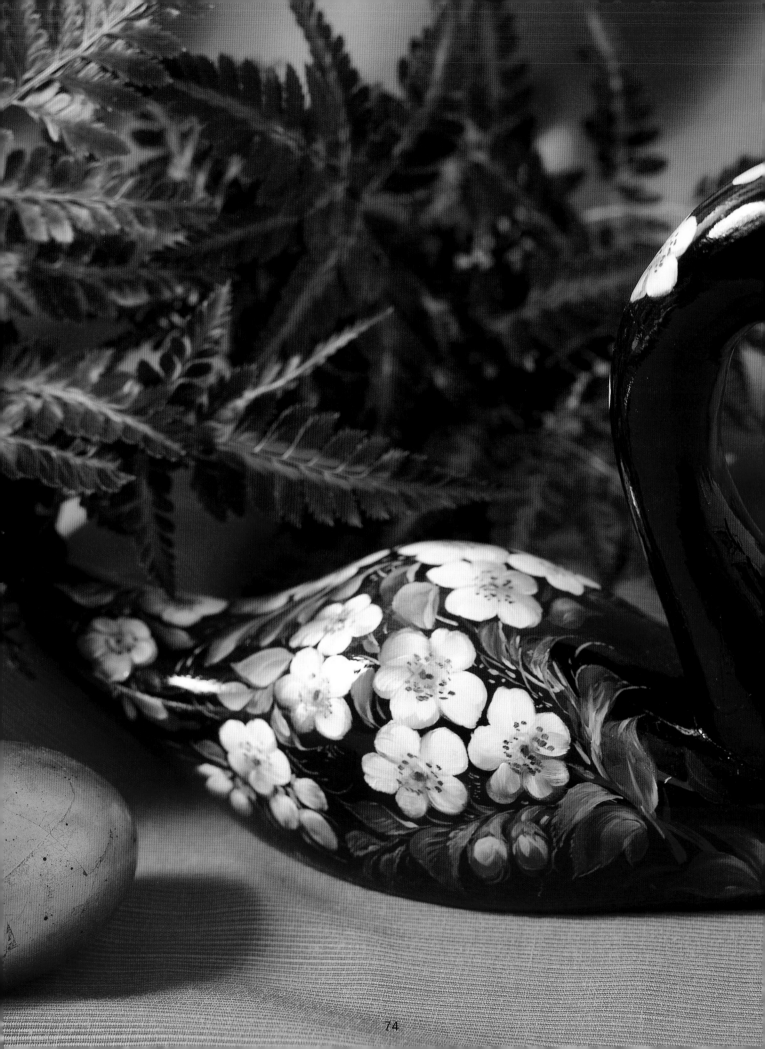

COMPOSITION OF CHERRY BLOSSOMS

Композиция вишневый цвет

Boris painted this Swan one night as a special gift for Alta Bradberry. If you will closely examine the looseness and playfulness in the way it is painted, you can see him smiling!

Composition of Cherry Blossoms SWAN

COLOR PALETTE

Alizarin Crimson
Cadmium Red Deep
Cadmium Red Light
Cadmium Yellow Light
Cadmium Yellow Medium
Sap Green
White

OTHER SUPPLIES

Craft Acrylic Paint:
 Black
 White
Brushes:
 Small (#2, #4 or #6)
 Medium (#8 or #10)
 Large (#12 or #14)
 Liner, #1, 1/0, or scroll brush
Painting Surface:
 Wooden swan

PROJECT INSTRUCTIONS

Preparation:
1. Brush on a light coat of wood sealer.
2. Basecoat the swan by brushing on two or three coats of black acrylic paint. Let the paint dry and sand after each coat with very soft steel wool. Sand after the last coat with a crumpled piece of brown paper bag with no printing on it. Wipe with a tack cloth.
3. Seal with matte acrylic spray. Let dry. Rub lightly again with the brown bag. Wipe all of the residue off with the tack cloth.
4. Neatly transfer the design, using chalk.

Undercoating:
1. Undercoat the entire design with white acrylic paint. Let dry.
2. Scrape over only the design with a razor blade. Wipe off the residue.
3. Rub on a thin layer of linseed oil.

Leaves:
Refer to Leaf Painting Worksheet, using colors given here.
1. Apply Alizarin Crimson to the tips of the leaves.
2. Apply Cadmium Yellow Medium as shown on the worksheet and blend lightly where the colors meet.
3. Brush over the yellow with Sap Green.
4. Define the vein with Alizarin Crimson.
5. Mix a touch of Cadmium Yellow Light with Sap Green. Fill in the area near the stem with this mix, using an S-stroke. With a feather touch, stroke over the leaf to softly blend the colors together.
6. Using Cadmium Yellow Light, stroke highlights as shown on worksheet.
7. Fill an excellent liner brush with thinned Cadmium Yellow Light and carefully paint the broken linework on and around each leaf.

Blossoms:
Refer to Small Blossoms Painting Worksheet.
1. Brush Cadmium Yellow Light in and around the center, letting a touch of it come onto each petal.
2. Shade two of the petal tips with Alizarin Crimson. Softly blend where the edges of the colors meet.
3. Shade the base of each petal with a little Sap Green. Add a touch of Sap Green on the outer edge of the three upper petals.
4. Mix Cadmium Red Light + White (a 1:4 ratio). Lightly stroke over each petal.

Continued on next page

76

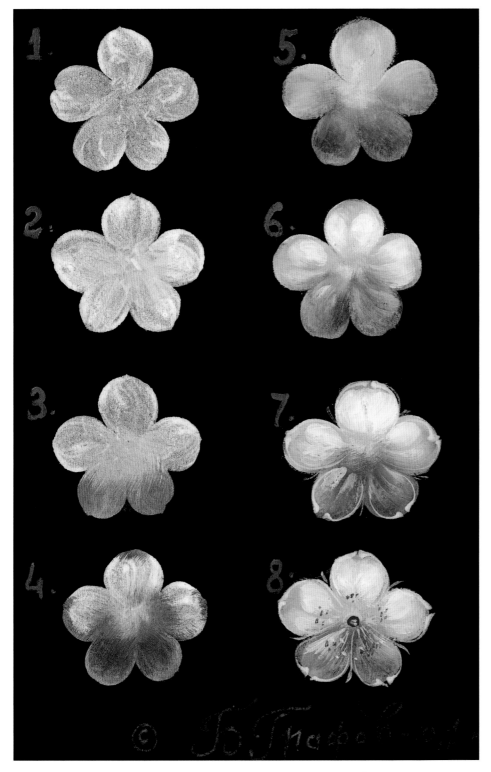

5. Overstroke the petals with White, using short strokes. Paint the lightest petals first.
6. Touch the center with a dot of Cadmium Red Deep. Make smaller dots on each petal with Cadmium Red Deep, Sap Green, and Cadmium Yellow Light. Highlight the centers with Cadmium Yellow Light.

Linework:
1. Mix a touch of Sap Green + Cadmium Yellow Light. Thin the mixture with turpenoid and linseed oil to a flowing consistency.
2. Complete the grass-like linework around the design.

Finishing:
1. Let the paint dry completely.
2. Finish with several coats of high gloss varnish. (See Varnishing section). ❏

Small Blossom Painting Worksheet

1. Undercoat.
2. Brush on Cadmium Yellow Light.
3. Shade with Alizarin Crimson. Blend where edges meet.
4. Shade with Sap Green.
5. Stroke over petals with Cadmium Red Light + White.
6. Overstroke with White.
7. Outline with thinned White.
8. Add Cadmium Red Deep dots. Add White dots. Add Cadmium Yellow Light dots.
Connect dots to center with Cadmium Yellow Light.

Patterns for Blossoms
on Swan

(actual size)

Right Side

Neck

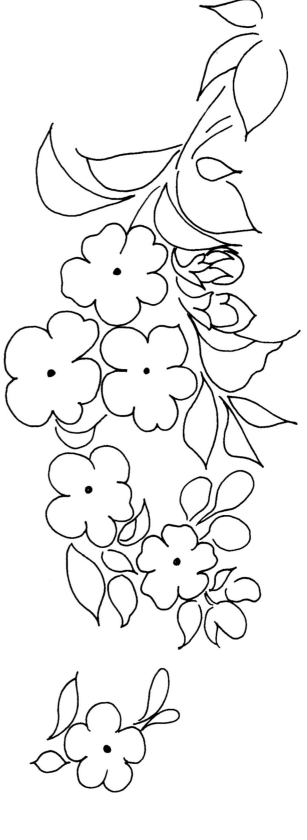

Patterns for Blossoms on Swan
(actual size)

Left Side

Center Back

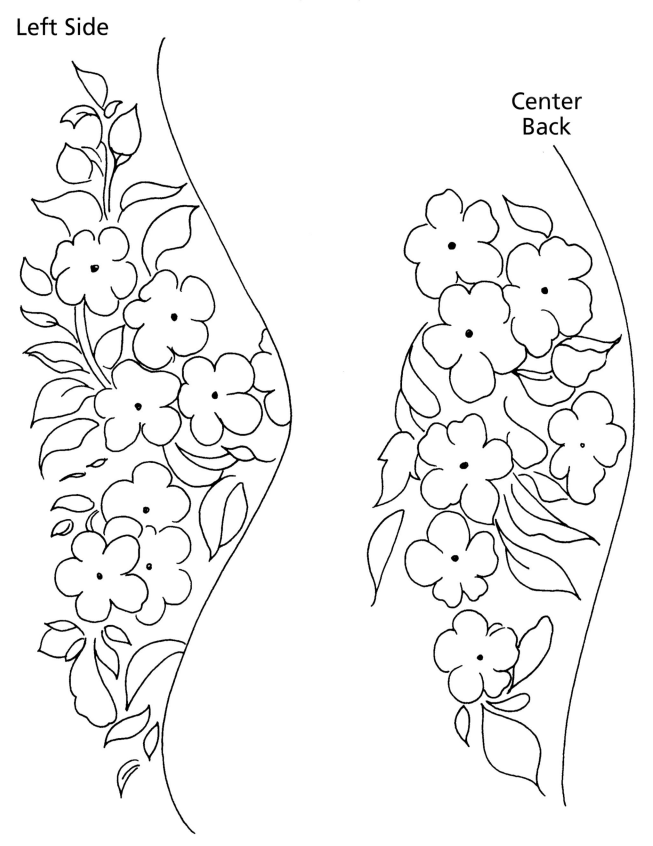

COMPOSITION OF GARDEN FLOWERS

Композиция садовые цветы

Two showy flowers combine in this design for a dramatic floral bouquet. The many-petalled **roses** and **dahlia** create a painting with a wonderful textural quality.

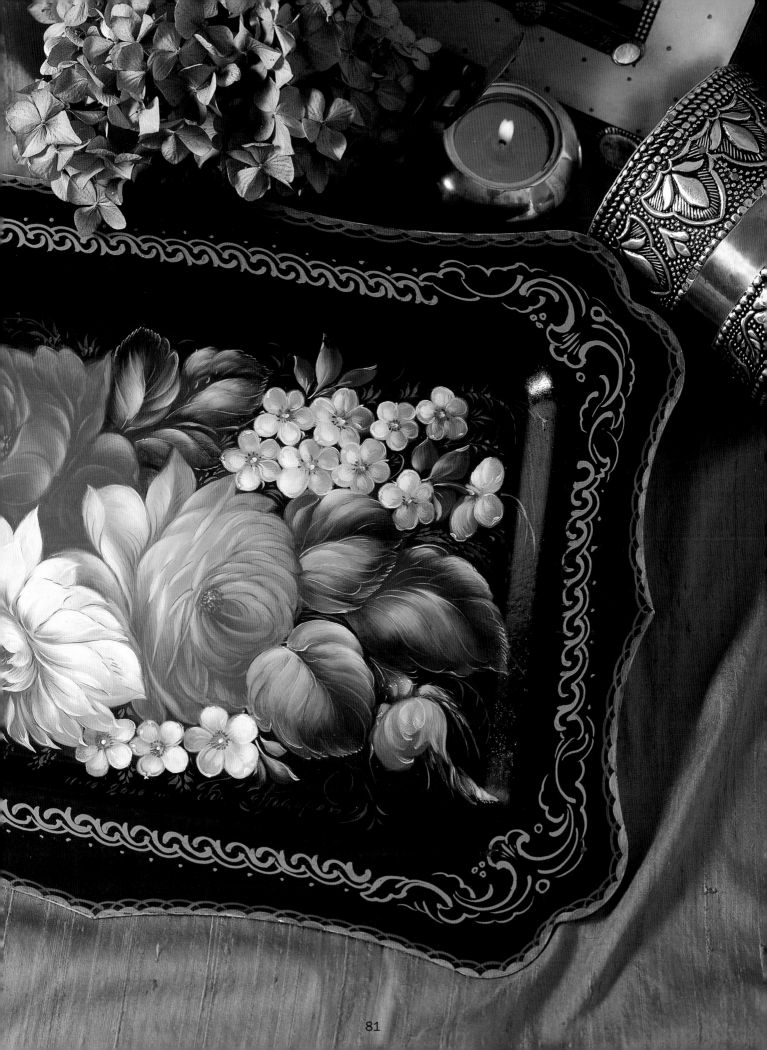

Composition of Garden Flowers TRAY

COLOR PALETTE

Alizarin Crimson
Asphaltum
Black
Cadmium Orange
Cadmium Red Deep
Cadmium Red Light
Cadmium Yellow Light
Cadmium Yellow Medium
Prussian Blue
Sap Green
Viridian
White
Metallic Gold

OTHER SUPPLIES

Craft Acrylic Paint:
 White
Spray Paint:
 Flat black
Brushes:
 Small (#2, #4 or #6)
 Medium (#8 or #10)
 Large (#12 or #14)
 Liner, #1, 1/0, or scroll brush
Mediums:
 Turpenoid
 Linseed Oil
Painting Surface:
 Rectangular metal tray

PROJECT INSTRUCTIONS

Preparation:

1. Basecoat the tray by spraying on two or three coats of flat black paint. Let the paint dry and sand after each coat with very soft steel wool. Wipe all of the residue off with a tack cloth. Sand after the last coat with a crumpled piece of brown paper bag with no printing on it. Wipe with a tack cloth.
2. Seal with matte acrylic spray. Let dry. Rub lightly again with the brown bag. Wipe off all of the residue with the tack cloth.
3. Neatly transfer the design, using chalk.

Undercoating:

1. Undercoat the design with white acrylic paint, using the same strokes that you will use to paint the design. Let dry.
2. Use a single edged razor blade to scrape the entire design. (Hold the razor blade straight up to keep from gouging the surface.) Sand lightly with a brown paper bag. Wipe off the residue.
3. Apply a very thin layer of linseed oil to undercoating with a small piece of cotton cloth.

Leaves:

Refer to Leaf Painting Worksheet.

1. Brush Alizarin Crimson onto the leaf tips, the buds, and on the edges of the petals of the two roses.
2. Apply Cadmium Yellow Medium to the centers of the leaves. Blend softly where the two colors meet.

Continued on page 84

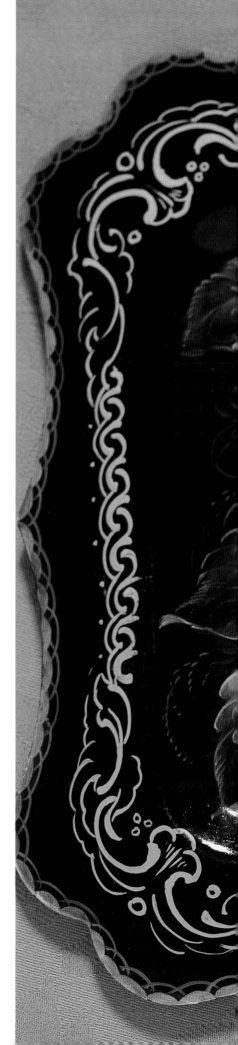

Continued from page 82

3. Brush-mix Sap Green + Viridian. Vary the color of the leaves by using a little more Sap Green on some of the leaves and a little more Viridian on others. Brush the mixes over leaves, allowing some of the colors beneath to show through.
4. Define the veins down the center of the leaves with Alizarin Crimson.
5. Brush-mix Prussian Blue + White to make a medium value ice blue mix. Brush this mix on the leaves to fill in the top one-third of each leaf.
6. Add more White to the ice blue mix to make an ice blue light mix. Using a variation of the S- stroke, pull the ice blue light mix in the lightest area of the leaves.
7. Brush on White highlights.
8. Thin the ice blue mix to a flowing consistency. Fill the liner brush completely. Paint the broken linework on and around the leaves.

Small Blossoms:
Refer to Small Blossom Painting Worksheet.
1. Brush Cadmium Yellow Light in and around the center, letting a touch of it come onto each petal.
2. Shade two of the petal tips with Alizarin Crimson. Softly blend where the edges of the colors meet.
3. Shade the base of each petal with a little Sap Green. Add a touch of Sap Green on the outer edge of the three upper petals.
4. Mix Cadmium Red Light + White (a 1:4 ratio). Lightly stroke over each petal.
5. Overstroke the petals with White, using short strokes. Paint the lightest petals first.
6. Fill the liner brush with White thinned with a touch of linseed oil mixed with a touch of turpenoid. Make thin comma strokes around each petal as shown on the worksheet.
7. Touch the center with a dot of Cadmium Red Deep. Make smaller dots on each petal as shown on the worksheet. Make fine lines on each petal with thinned White. Add dots of White on the petals. Highlight the centers with a touch of Cadmium Yellow Light. Draw very fine lines that connect the dots on the petals to the center with the Cadmium Yellow Light.

Red Rose:
Refer to the photos for Painting a Rose, using colors given here.
1. Brush Alizarin Crimson on the edges of the petals and to form the center.
2. Brush Cadmium Red Deep over the outer edges of the petals on the shadow side and shape the lower bowl of the rose.
3. Fill in the back of the rose and the outer petals with Cadmium Red Light + a touch of White. Use a *very light touch* to paint these strokes. Brush this mix on the front of the rose bowl and on the front petals. Blend the colors softly together.
4. Add a touch more of the White to the mixture. Highlight the front petals.
5. Continue to form the edges of the petals.
6. Apply dots of White, Cadmium Yellow Light, and Cadmium Orange to the center area of the rose.
7. Thin Cadmium Orange to a flowing consistency. Fill your liner brush and paint the linework on the rose.

Coral Rose & Bud:
Refer to the photos for Painting a Rose, using colors given here.
1. Brush Alizarin Crimson on the edges of the petals on the shadow side of the rose. Use Alizarin Crimson to form the center.
2. Paint the bud with Cadmium Red Deep.
3. Brush Cadmium Red Deep to form the center and to shape the lower bowl of the rose.
4. Fill in the back of the rose and the outer petals with Cadmium Orange, softly blending the colors together. Brush Cadmium Orange to form the petals on the bud.
5. Brush-mix White + Cadmium Orange (a coral color). Brush this mix on the front of the rose bowl and on the front petals. Blend the colors together softly.
6. Add a touch more of White to the coral mix. Define the front petals.
7. Continue to form the highlights and the edges of the petals on the rose and on the bud.
8. Apply dots of White, Cadmium Yellow Light, Cadmium Orange, and Cadmium Red Deep to the center area of the rose.
9. Thin Cadmium Red Deep to a flowing consistency. Fill the liner brush. Paint the linework in the rose.
10. Thin Cadmium Orange to a flowing consistency. Fill the liner. Paint the linework around the rose.
11. Thin White and add a few lines on the bud using the liner brush.

Continued on page 86

Dahlia Painting Worksheets

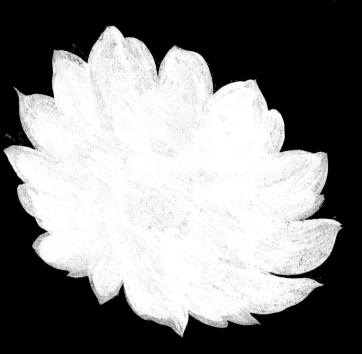

Illus. A
1. Undercoat. Let dry.
2. Rub on thin layer of linseed oil.

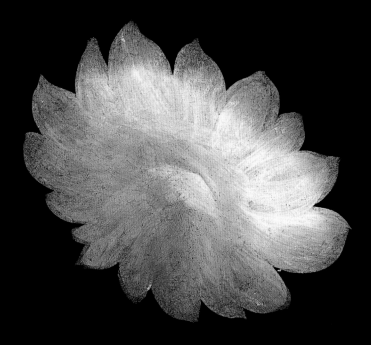

Illus. B
1. Brush small amount Viridian + Black over outer edges of petals.
2. Apply Met. Gold + Asphaltum around center. Brush over lower petals.

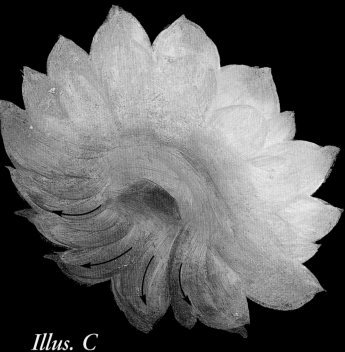

Illus. C
1. Overstroke petals with Ice Blue mix.
2. Mix Cadmium Red Deep + ice blue mix. Overstroke bottom petals.
3. Form center with mix of Cadmium Red Deep + ice blue mix.

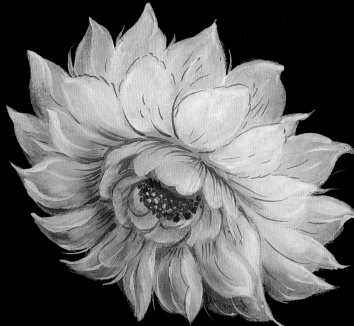

Illus. D
1. Stroke in middle layer of petals with White.
2. Form center with short comma-like strokes.
3. Apply dots of Cadmium Red Deep, Cadmium Red Light, and Cadmium Yellow Light into center.
4. Linework with White around petals.
5. Fine linework with Cadmium Red Deep.

Continued from page 84

Dahlia:

Refer to the Dahlia Painting Worksheet.

ILLUSTRATION A:

1. Undercoat the design with white acrylic paint. Let dry.
2. Rub a thin layer of linseed oil on the undercoating with a small piece of cotton cloth.

ILLUSTRATION B:

3. Mix Viridian + Black (a 5:1 ratio), and brush a small amount over the outer edges of the petals.
4. Mix Asphaltum + Metallic Gold (a 3:1 ratio), and apply around the center, gently brushing the Asphaltum over the lower petals.

ILLUSTRATION C:

5. Mix Prussian Blue + White (a 1:10 ratio). Stroke over the petals with a very thin layer of this ice blue mix.
6. Mix a touch of Cadmium Red Deep + the ice blue mix. Overstroke the bottom petals as illustrated. (When you form the petals in the back of the flower, add a touch of Cadmium Orange to the Cadmium Red Deep to give it the glow.)
7. Form the center with the Cadmium Red Deep/ice blue mix.

ILLUSTRATION D:

8. To finish the flower, stroke in the middle layer of petals with White.
9. Apply short comma-like strokes of White to form the center petals.
10. Apply dots of Cadmium Red Deep, Cadmium Red Light, and Cadmium Yellow Light into the center.
11. Thin White and paint linework around the petals as illustrated.
12. Thin Cadmium Red Deep with linseed oil to a flowing consistency and paint the linework as illustrated.

Linework:

1. Mix together colors from your palette and thin with turpenoid and linseed oil (a 1:1:1 ratio), to a flowing consistency.
2. Loosely paint the grass around the design.

Border:

1. Thin Metallic Gold paint with turpenoid and linseed oil (a 1:1:1 ratio).
2. Paint the border of your choice around the design. ❑

Pattern for Tray

(actual size)

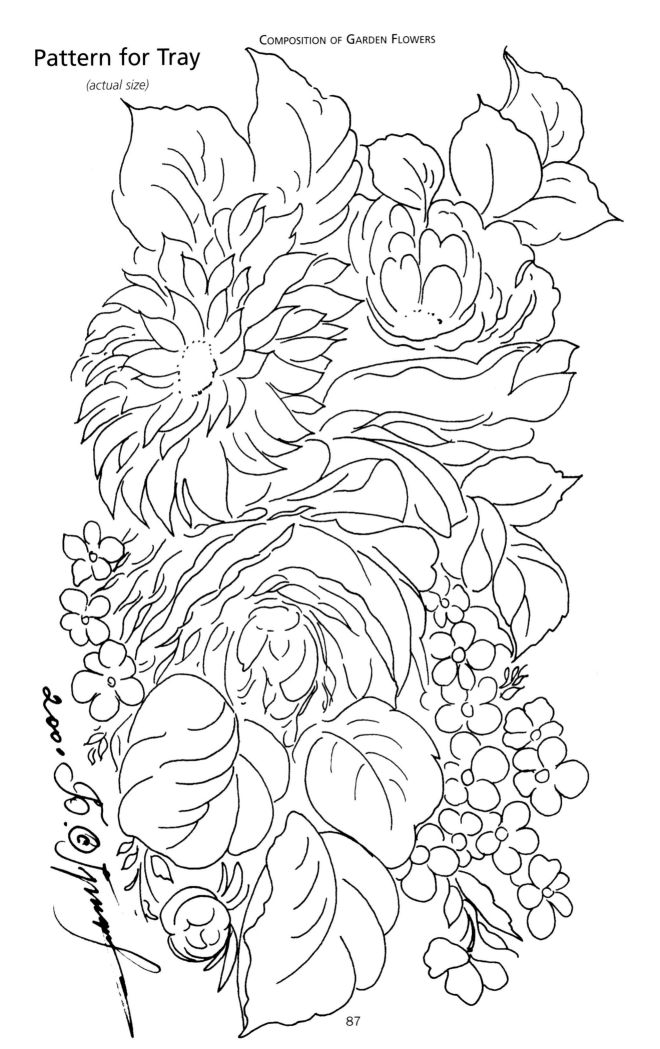

WALTZ OF FLOWERS

Вальс цветов

The bowl looks like a piece of china painting! I had some friends tell me they thought it would break. It will make your heart sing!

The colors in these roses vary according to the amount of each color that you have in the brush. Don't try to copy exactly. Just loosen up and I'm sure they will be fabulous!

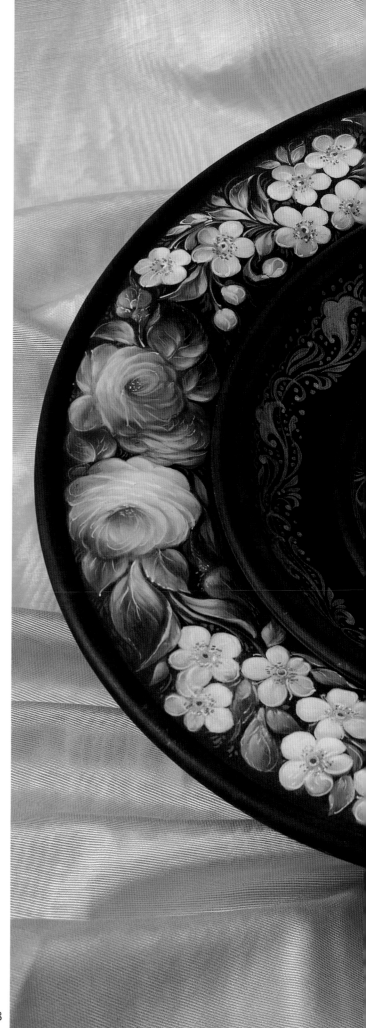

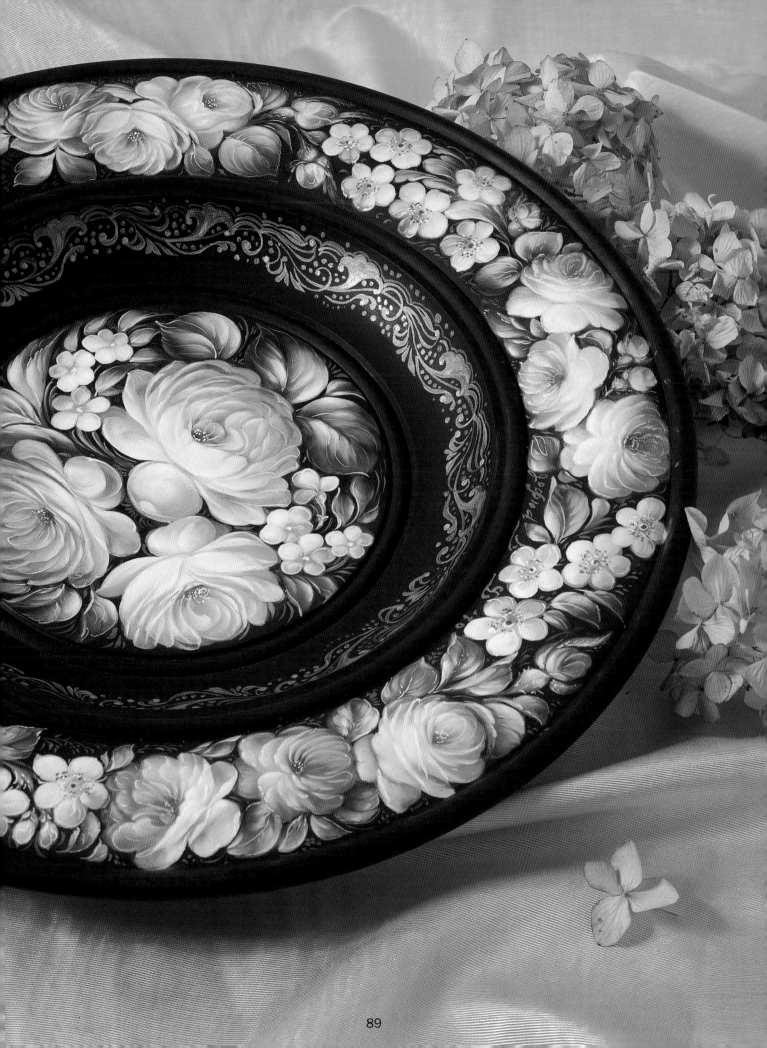

Waltz of Flowers BOWL

COLOR PALETTE

Alizarin Crimson
Asphaltum
Black
Cadmium Orange
Cadmium Red Light
Cadmium Red Medium
Cadmium Yellow Deep
Cadmium Yellow Light
Cadmium Yellow Medium
Prussian Blue
Sap Green
Viridian
White
Metallic Gold
Metallic Silver

OTHER SUPPLIES

Acrylic Craft Paints:
 Black
 White
Brushes:
 Small (#2, #4, or #6)
 Medium (#8 or #10)
 Large (#12 or #14)
 Liner, #1, 1/0, or scroll brush
Mediums:
 Turpenoid
 Linseed Oil
Painting Surface:
 Wooden bowl

PROJECT INSTRUCTIONS

TIP: Here's is the best painting order. The design in the center of the bowl should be painted first. Paint the gold and silver border. Paint the border of roses on the band last. (This will help keep your hands out of the wet paint.)

Preparation:

1. Basecoat the bowl by brushing on two or three coats of black acrylic paint. Let the paint dry and sand after each coat with a crumpled piece of brown paper bag with no printing on it. Wipe off all of the residue with a tack cloth. Sand after the last coat with a crumpled piece of brown paper bag. Wipe with a tack cloth.
2. Seal with matte acrylic spray. Let dry. Rub lightly again with the brown bag. Wipe off all of the residue with the tack cloth.
3. Neatly transfer the design, using chalk.

Undercoating:

1. Undercoat the design with white acrylic paint, using the same strokes that you will use to paint the design.
2. Use a single edged razor blade to scrape the entire design. (Hold the razor blade straight up to keep from gouging the surface.)
3. Apply a very thin layer of linseed oil to the undercoating with a small piece of cotton cloth.

Leaves:

Refer to Leaf Painting Worksheet, using colors given here.

1. Apply Asphaltum to the leaf tips.
2. Brush over the Asphaltum with Alizarin Crimson on some of the leaf tips and on the stems.
3. Brush Cadmium Yellow Light about two-thirds of the way up the leaf and lightly blend.
4. Brush over the yellow with Sap Green. Define the vein with Viridian + a touch of Sap Green. Apply a tiny touch of Viridian + Sap Green over some of the tips as well as the base of the leaves.
5. Mix Viridian + touch of White to make an ice blue mix. Fill in the area near the stem with this mix, using a variation of the S-stroke. With a very light touch, stroke over the rest of the leaf to softly blend the colors together.
6. Using White, stroke in the highlights as shown in the photo of the finished project.
7. Fill an excellent liner brush with the thinned ice blue mix. Carefully paint the broken linework around the leaves.

Continued on page 92

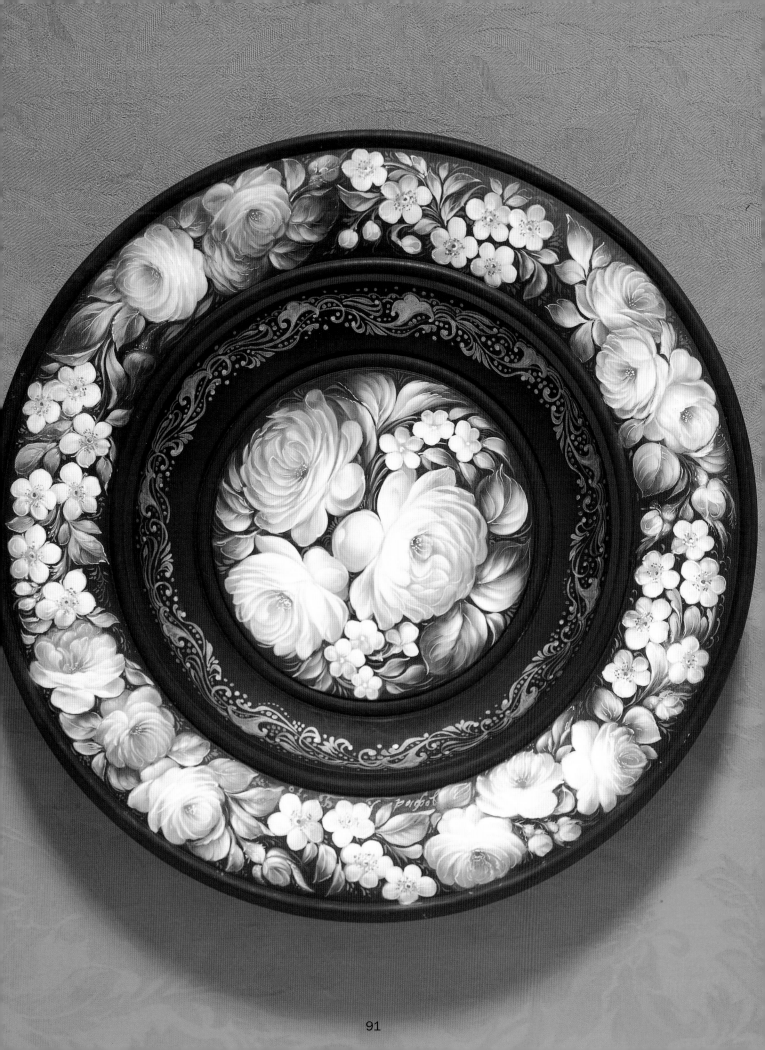

Continued from page 90

Blossoms:

Refer to the Small Blossom Painting Worksheet, using colors given here.

Paint the blossoms in the center of the bowl according to the worksheet. When painting the blossoms on the border, substitute Cadmium Yellow Medium for the Alizarin Crimson. (This gives you a lighter colored blossom.)

White Roses:

Refer to the step-by-step photos in "Painting a Rose" section, using colors given here.

1. Brush Cadmium Yellow Deep around the outer edges of the roses and in their centers.
2. Brush Sap Green in the centers to deepen the color.
3. Brush Cadmium Yellow Light around the center, letting it come onto each petal.
4. Shade two of the petal tips in the back of the roses with Cadmium Orange. Softly blend where the edges of the colors meet.
5. Shade the outer edges of the roses with Sap Green, softly blending where two colors meet. (Do not bring the Sap Green over the front of the bowl of the rose.)
6. Mix Sap Green + Cadmium Yellow Light + White. Lightly stroke to form each petal.
7. Overstroke the petals with White. Paint the lightest petals first.
8. Brush the highlights on the front of the bowl of the rose with White.
9. Fill the liner brush with White thinned with a touch of linseed oil mixed with a touch of turpenoid. Paint the thin lines in and around the roses.
10. Touch the center with dots of the White.

Coral Roses & Buds:

Refer to the step-by-step photos in "Painting a Rose" section, using colors given here.

1. Brush Cadmium Orange onto back section of the coral roses and buds.
2. Softly blend the edges where the two colors (Cadmium

Orange and the Alizarin Crimson from the leaf section) meet.
3. Brush on Cadmium Red Medium to form the petals on the shadow side of the roses and the buds.
4. Brush-mix Cadmium Red Light + White and form the bowls of the roses, the front petals, and the fronts of the buds. Softly blend where the colors meet.
5. Add a little more White to the mix. Form the edges of the petals on the roses and the buds.
6. Using the White that's in the brush, paint the highlights on the lower petals.
7. Thin the White to a flowing consistency. Fill the liner brush and paint the linework on roses and buds.
8. Make a few dots of White in the center of the roses.

Yellow Roses & Buds:

Refer to the step-by-step photos in "Painting a Rose" section, using colors given here.

1. Brush Asphaltum onto the outer edges of the roses and on the buds.
2. Brush a very thin layer of Sap Green over the Asphaltum.
3. Brush on Cadmium Yellow Medium to form the petals on the roses and the buds.
4. Brush-mix White + a touch of Cadmium Yellow Light. Form the edges of the petals on the bowl of the roses and on the buds. Stroke in the highlights on the lower petals.
5. Thin Cadmium Yellow Light + White to a flowing consistency. Fill your liner brush and paint the dots in the center of the roses and buds.

Linework:

Thin Viridian + a touch of White to a flowing consistency. Paint the grass-like linework around the design.

Center Border:

1. Thin Metallic Gold to a flowing consistency. Fill your liner brush completely full and paint the Gold strokes first.
2. Change to the Silver thinned in the same manner as the gold and complete the design. ❏

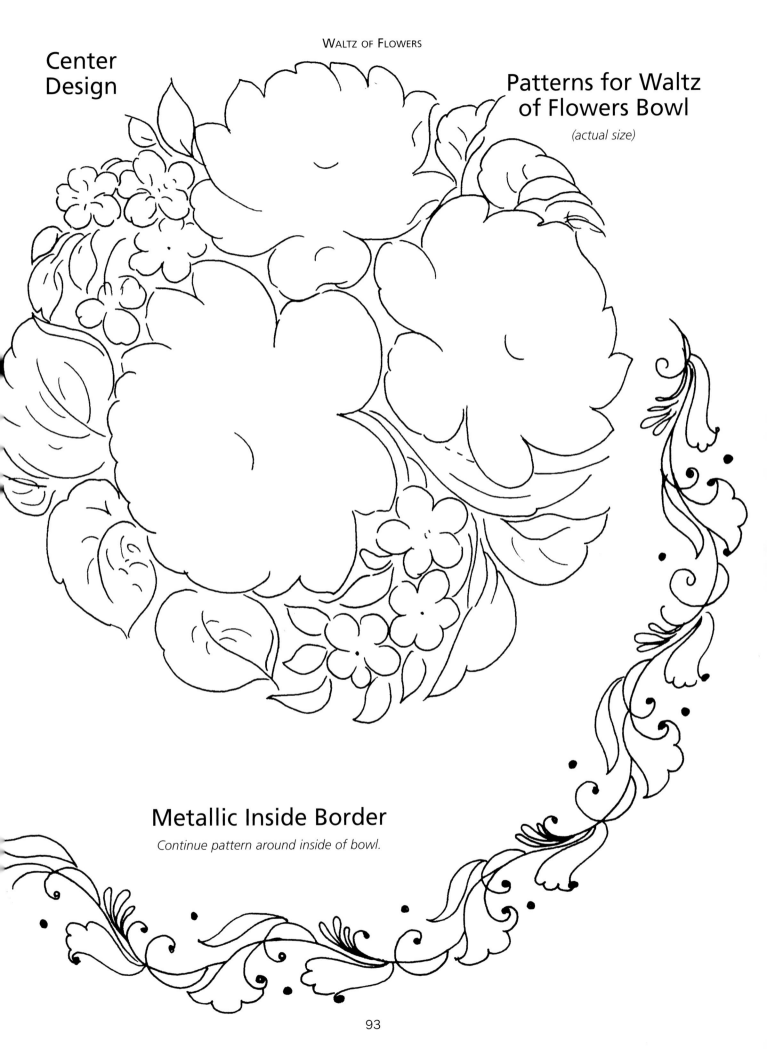

Center Design

Patterns for Waltz of Flowers Bowl

(actual size)

Metallic Inside Border

Continue pattern around inside of bowl.

Patterns for Outer Floral Border

(actual size)

Section A

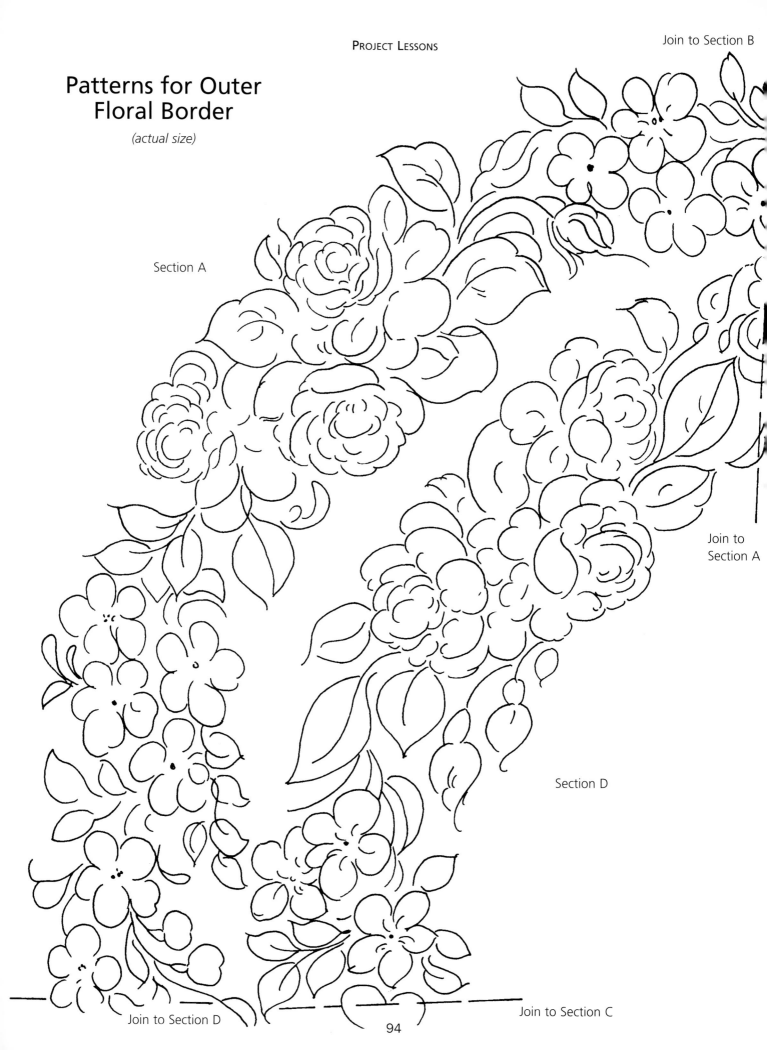

Join to Section B

Join to Section A

Section D

Join to Section D

Join to Section C

Join to Section A

Join sections of pattern at dotted lines to complete.

Section B

Join to Section B

Section C

Join to Section D

Join to Section C

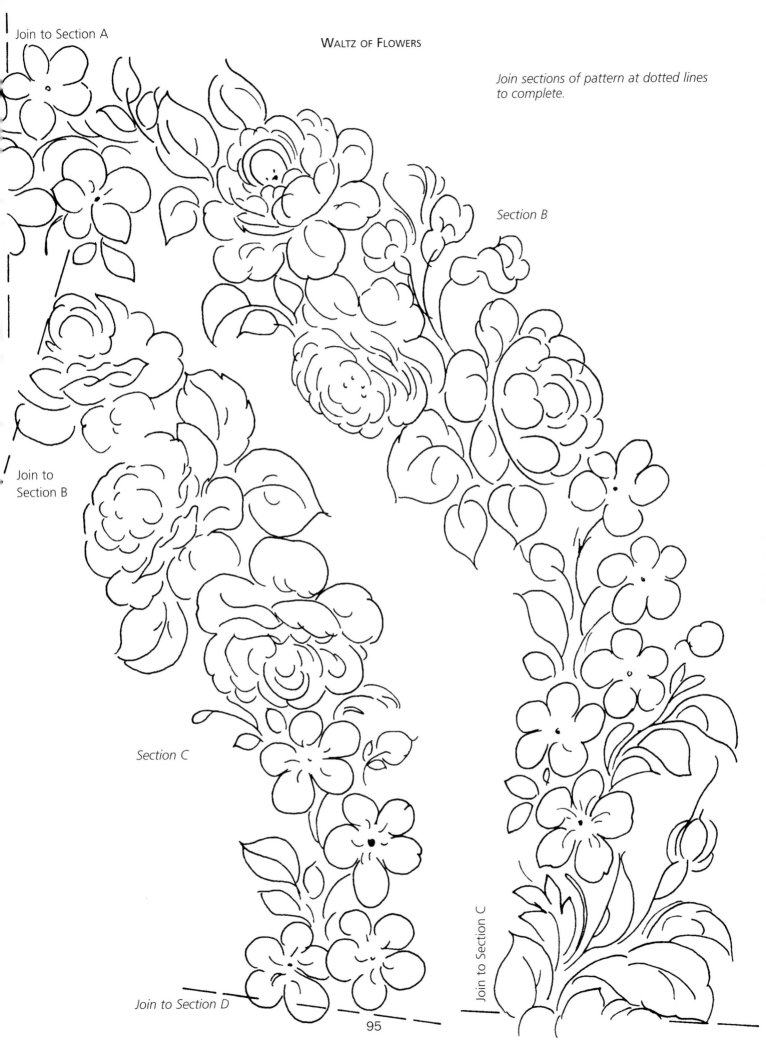

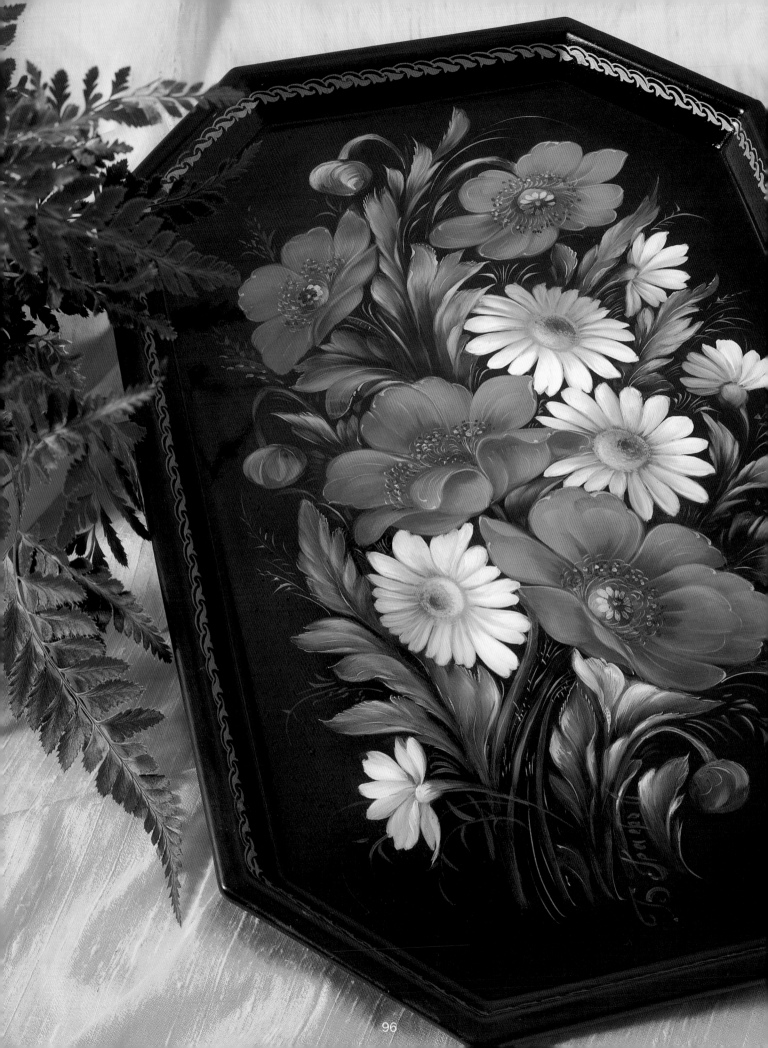

Wild Flowers

Полевые цветы

The happy **poppy** and the friendly
daisy combine here for a bouquet
that's full of beauty and good feelings.

Wild Flowers TRAY

COLOR PALETTE

Asphaltum
Black
Cadmium Orange
Cadmium Red Light
Cadmium Red Medium
Cadmium Red Deep
Cadmium Yellow Light
Cadmium Yellow Medium
Prussian Blue
Sap Green
Viridian
White
Metallic Gold

OTHER SUPPLIES

Craft Acrylic Paint:
 White
Spray Paint:
 Flat black
Brushes:
 Small (#2, #4 or #6)
 Medium (#8 or #10)
 Large (#12 or #14)
 Liner, #1, 1/0, or scroll brush
Mediums:
 Turpenoid
 Linseed Oil
Painting Surface:
 Rectangular metal tray

PROJECT INSTRUCTIONS

Preparation:

1. Basecoat the tray by spraying on two or three coats of flat black paint. Let the paint dry and sand after each coat with very soft steel wool. Wipe all of the residue off with a tack cloth. Sand after the last coat with a crumpled piece of brown paper bag with no printing on it. Wipe with a tack cloth.
2. Seal with matte acrylic spray. Let dry. Rub lightly again with the brown bag. Wipe off all of the residue with the tack cloth.
3. Neatly transfer the design, using chalk.

Undercoating:

1. Undercoat the design with white acrylic paint, using the same strokes that you will use to paint the design.
2. Use a single edged razor blade to scrape the entire design. (Hold the razor blade straight up to keep from gouging the surface.)
3. Apply a very thin layer of linseed oil to the undercoating with a small piece of cotton cloth.

Leaves:

Refer to the leaves on Poppy Painting Worksheet.

1. Apply a small amount of Asphaltum to the tips of the leaves.
2. Paint the leaves with Viridian.
3. Shade the bases of the leaves with a small amount of thinned Black as seen on Illustration B of the worksheet.
4. Mix White + Prussian Blue to an ice blue dark mix. Overstroke the lightest areas of the leaves with this mix (Illustration C of the worksheet).
5. Add more White to the ice blue dark mix. Use this ice blue light mix to highlight the leaves.
6. Brush the strongest highlights on the leaves at the top of the design with a touch of Cadmium Yellow Light.

Continued on page 100

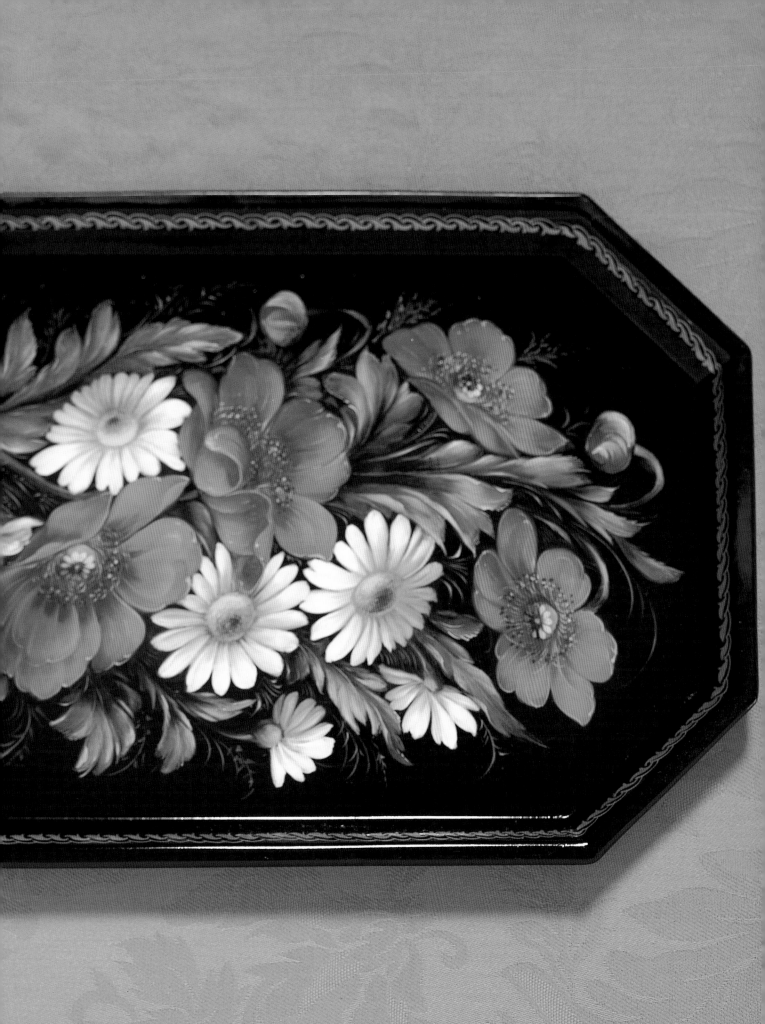

Continued from page 98

7. Brush a few touches of White highlights on the leaves underneath the bottom poppy.

8. Fill an excellent liner brush with thinned Cadmium Yellow Light and paint the broken linework on the leaves.

Daisies:

Refer to Daisy Painting Worksheet.

1. Brush on a little Asphaltum as illustrated on the worksheet.

2. Brush on a touch of Viridian around the established Asphaltum center.

3. Mix Prussian Blue + White (a 1:10 ratio) with a touch of linseed oil to make an ice blue color. Overstroke the top petals first with the ice blue mixture. Continue to paint the petals at the back, but do not pick up more of the ice blue paint.

4. Overstroke the top petals with White. Do not pick up more paint as you overstroke the back petals, allowing the dirty brush to do the shading. Dab more Sap Green on the top of the center as illustrated.

5. Blend Sap Green in the center.

6. Stipple around the center with Asphaltum and more Sap Green, if needed.

7. Stipple in the center with Cadmium Yellow Light dots. Stipple a touch of White for the highlight as shown on the worksheet.

8. Fill the liner brush with White paint thinned with a drop of linseed oil and a drop of turpenoid to a thin flowing consistency. Outline the bottom petals with fine lines. *TIP: It is easier to paint the fine linework after the petals have had a little time to dry.*

Poppies:

Refer to Poppy Painting Worksheet.

1. Shade the centers and front petals with Black as seen on Illustration A of the worksheet..

2. Apply a small amount of Asphaltum to the poppy centers.

3. Paint the poppy centers with Viridian.

4. Paint the poppy petals and buds with Cadmium Red Deep.

5. Shade the centers and the buds with a small amount of thinned Black as seen on Illustration B of the worksheet.

6. Shade the top poppy petals with the thinned Black.

7. Overstroke the lower poppy and the buds with Cadmium Red Medium.

8. Overstroke poppy petals and buds with Cadmium Orange. Dab Black dots on each of the poppy petals.

9. Mix Sap Green + Cadmium Yellow Light + a touch of Prussian Blue. Overstroke the poppy centers with this mix.

10. Poppy centers: Make a mix of Sap Green + Cadmium Yellow Light + White. Apply strokes, which look like a tiny daisy as seen on Illustration C of the worksheet. Add a dot to the center.

11. Mix Viridian + a touch of Black. Make smaller strokes like the daisy on the center of the top left poppy.

12. To finish, thin Cadmium Yellow Light with turpenoid and linseed oil to a flowing consistency. Paint beautiful broken linework on the poppies and the bud.

13. Add dots of Cadmium Yellow Light and ice blue mix on each petal. Connect these dots to the center with thinned Cadmium Yellow Light.

14. Paint the beautiful broken linework on the poppies and the buds with Cadmium Red Light.

Linework, Border & Finishing:

1. Use the thinned Cadmium Yellow Light to paint the linework around the design (instead of the Burnt Sienna shown on Poppy Painting Worksheet). This linework is often referred to as "grass."

2. Paint a beautiful border of your choice around the edge of the tray using thinned Metallic Gold. (See the border examples in Stroke Linework & Ornamentation Section.) Allow paint to dry thoroughly.

3. Following the directions in the Varnishing section, apply a glossy finish to the tray. ❑

1. Undercoat
2. Brush on Asphaltum.
3. Brush on Viridian around center.
4. Overstroke with ice blue mix,
 starting with top petals.

5. Overstroke with White.
6. Blend Sap Green in center.
7. Stipple Asphaltum in center.
 Add more Sap Green, if needed.

8. Stipple Cadmium Yellow Light
 dots in center.
 Stipple White highlights.
 Outline bottom petals.

Illus. A
Undercoat.
Shade with thinned Black.

Poppy Painting Worksheet

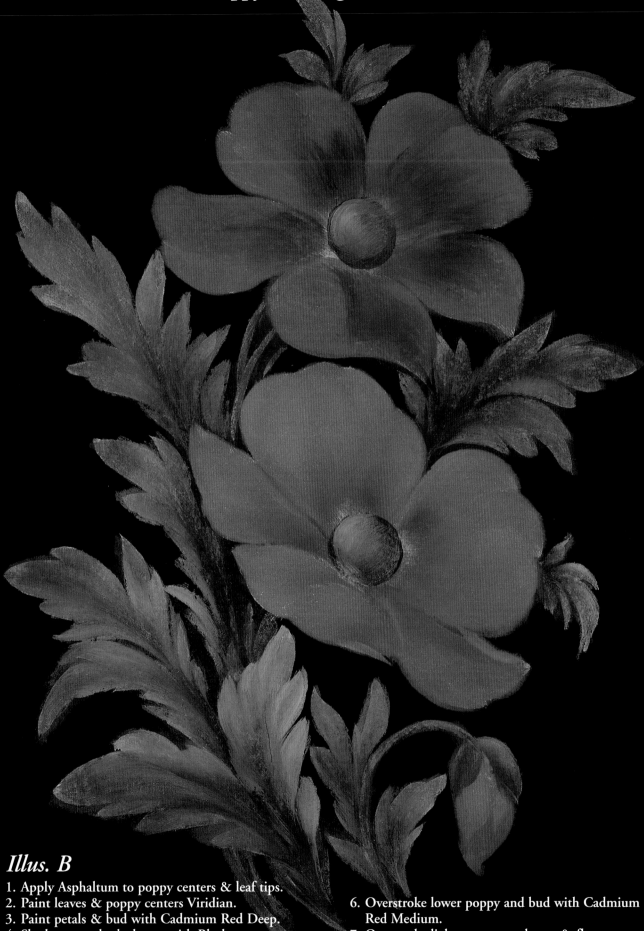

Illus. B

1. Apply Asphaltum to poppy centers & leaf tips.
2. Paint leaves & poppy centers Viridian.
3. Paint petals & bud with Cadmium Red Deep.
4. Shade center, buds, leaves with Black.
5. Shade upper petals Black.

6. Overstroke lower poppy and bud with Cadmium Red Medium.
7. Overstroke lightest areas on leaves & flower centers with ice blue mix.

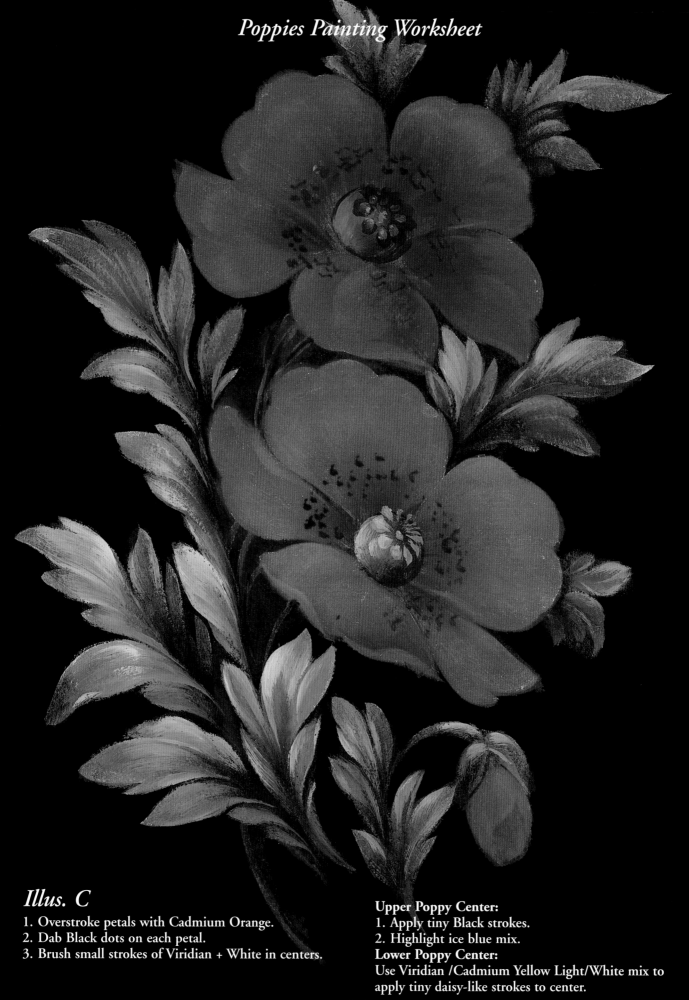

Illus. C

1. Overstroke petals with Cadmium Orange.
2. Dab Black dots on each petal.
3. Brush small strokes of Viridian + White in centers.

Upper Poppy Center:
1. Apply tiny Black strokes.
2. Highlight ice blue mix.

Lower Poppy Center:
Use Viridian /Cadmium Yellow Light/White mix to apply tiny daisy-like strokes to center.

Illus. D

1. Linework on poppies and bud – thinned Cadmium Red Light.
2. Add dots of Cadmium Yellow Light, Cadmium Orange to each petal. Connect dots to center with thinned Cadmium Yellow Light lines.
3. Cadmium Yellow Light linework on leaves.
4. Tiny daily-like strokes – Viridian/Cadmium Yellow Light/White mix.
5. "Grass" – thinned Burnt Sienna.

Pattern for Wild Flowers Tray

(actual size)

Section A

Join patterns at dotted lines to complete.

Section B

MANY
RED
ROSES

Красные розы

The lavenders and the rich reds make
this tray absolutely stunning! It will
not only cheer your heart to paint it,
but it will brighten all the days that
follow while you display or use it.

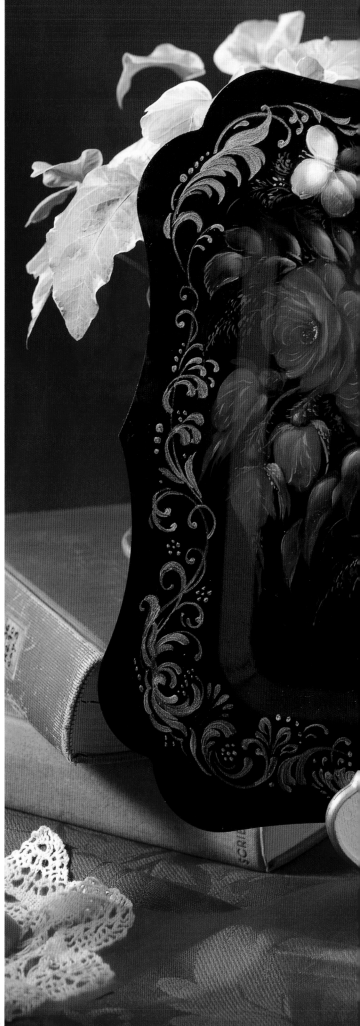

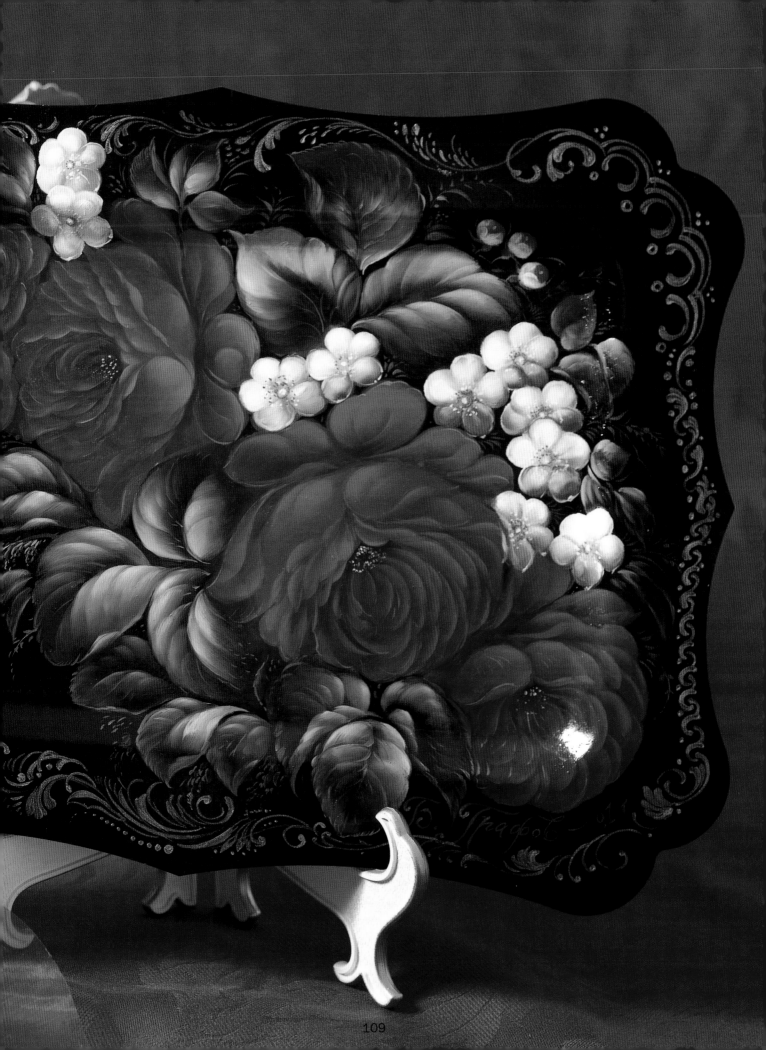

Many Red Roses TRAY

COLOR PALETTE

Alizarin Crimson
Cadmium Red Light
Cadmium Red Medium
Cadmium Yellow Light
Cadmium Yellow Medium
Prussian Blue
Sap Green
Viridian
White
Metallic Gold

OTHER SUPPLIES

Craft Acrylic Paint:
 White
Spray Paint:
 Flat black
Brushes:
 Small (#2, #4 or #6)
 Medium (#8 or #10)
 Large (#12 or #14)
 Liner, #1, 1/0, or scroll brush
Mediums:
 Turpenoid
 Linseed Oil
Painting Surface:
 Rectangular metal tray

Continued on page 112

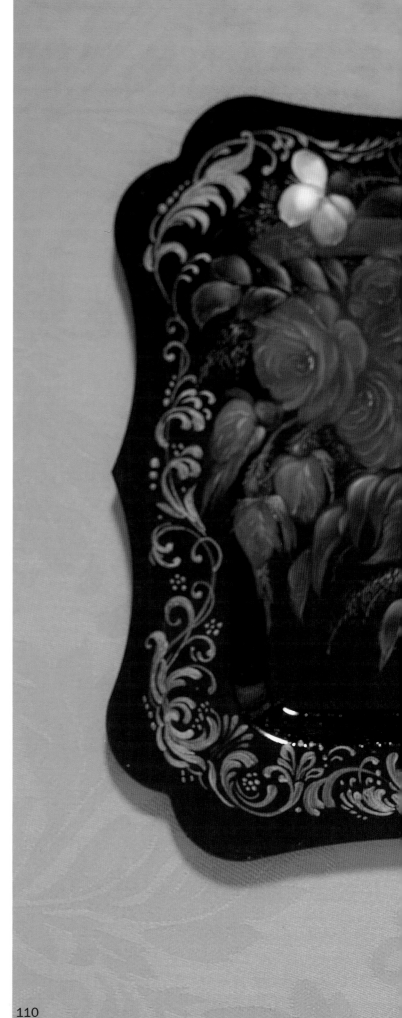

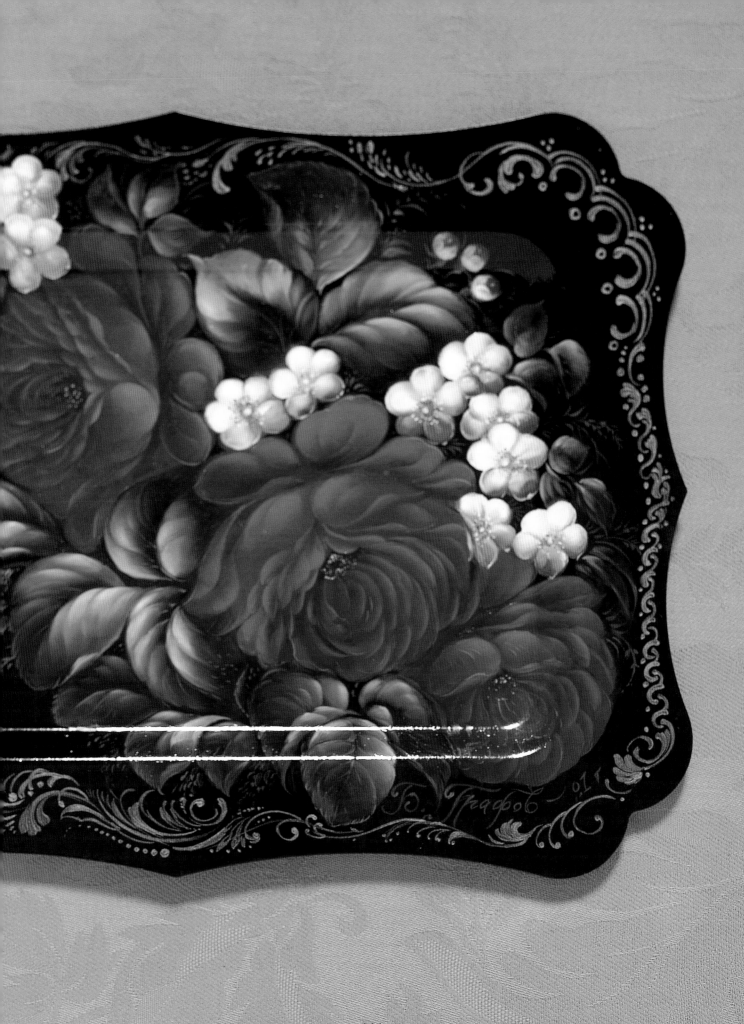

Continued from page 110

PROJECT INSTRUCTIONS

Preparation:

1. Basecoat the tray by spraying on two or three coats of flat black paint. Let the paint dry and sand after each coat with very soft steel wool. Wipe all of the residue off with a tack cloth. Sand after the last coat with a crumpled piece of brown paper bag with no printing on it. Wipe with a tack cloth.
2. Seal with matte acrylic spray. Let dry. Rub lightly again with the brown bag. Wipe off all of the residue with the tack cloth.
3. Neatly transfer the design, using chalk.

Undercoating:

1. Undercoat the design with white acrylic paint, using the same strokes that you will use to paint the design. Let dry.
2. Use a single edged razor blade to scrape the entire design. (Hold the razor blade straight up to keep from gouging the surface.) Sand lightly with a brown paper bag. Wipe off the residue.
3. Apply a very thin layer of linseed oil to undercoating with a small piece of cotton cloth.

Leaves:

Refer to Leaf Painting Worksheet, using colors given here.

1. Brush Alizarin Crimson onto the leaf tips, the buds, and on the edges of the petals of the roses.
2. Apply Cadmium Yellow Medium to the centers of the leaves. Blend softly where the two colors meet.
3. Brush-mix Sap Green + Viridian. Brush over leaves, allowing some of the colors beneath to show through.
4. Define the veins down the center of the leaves with the Sap Green/Viridian mix + a touch of Prussian Blue.
5. Brush-mix Prussian Blue + White to make an ice blue mix. Using a variation of the S-stroke, pull the ice blue mix in the lightest area of the leaves.
6. Brush on White highlights.

7. Thin the ice blue mix to a flowing consistency. Fill the liner brush completely. Paint the broken linework on and around the leaves.

Small Blossoms:

Refer to Small Blossom Painting Worksheet.

Paint the blossoms as shown and directed in the worksheet.

Red Roses:

Refer to the step-by-step photos of Painting a Rose, using the colors given here.

1. Brush Alizarin Crimson on the edges of the petals and to form the center.
2. Brush Cadmium Red Deep over the outer edges of the petals and shape the lower bowl of the rose.
3. Brush-mix Prussian Blue + Alizarin Crimson + White to make a deep lavender color. Fill in the back of the larger roses, the small roses, and the buds with strokes of this mix.
4. Brush Cadmium Red Light on the front of the bowl of the larger roses and on their front petals. Blend the colors softly together.
5. Continue to form the edges of the petals with Cadmium Red Light.
6. Thin the lavender mix to a flowing consistency and paint the linework around the roses and the buds.
7. Thin Cadmium Yellow Light to a flowing consistency. Make tiny dots in the centers of the roses.

Linework & Border:

1. Thin the ice blue mix from the leaves to a flowing consistency. Fill the liner brush full of paint. Paint the grasses around the design.
2. Thin Metallic Gold paint with turpenoid and linseed oil (a 1:1:1 ratio). Paint the border of your choice around the design (Stroke Linework & Ornamentation Section). ❑

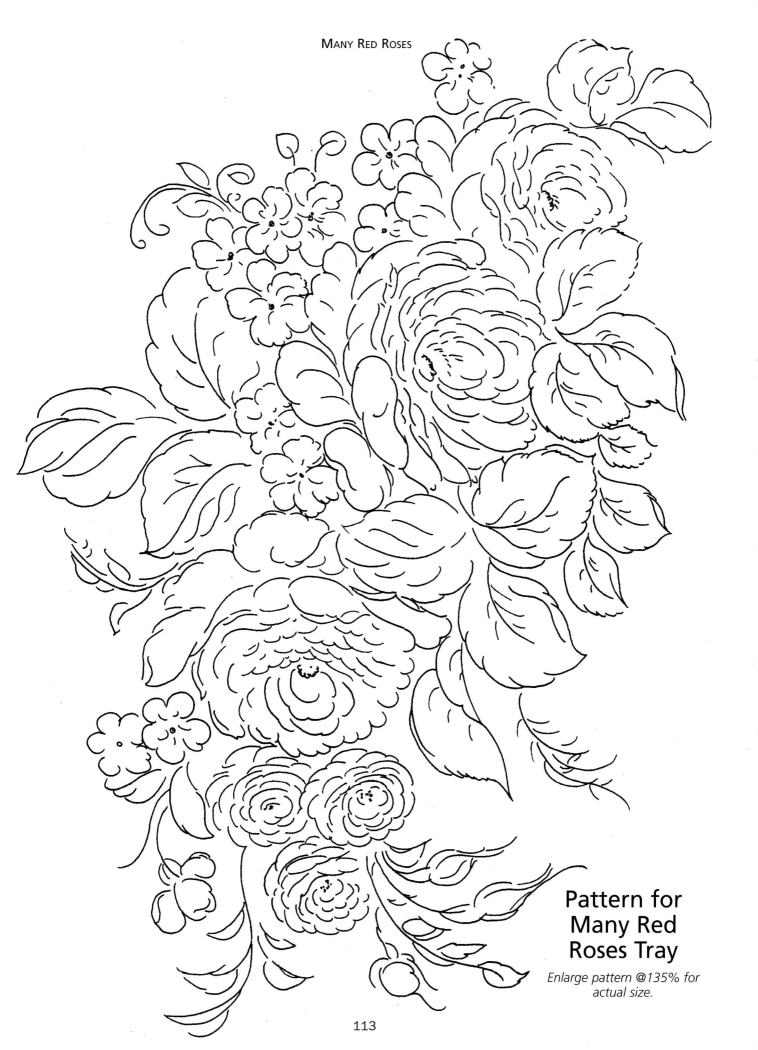

Pattern for Many Red Roses Tray

Enlarge pattern @135% for actual size.

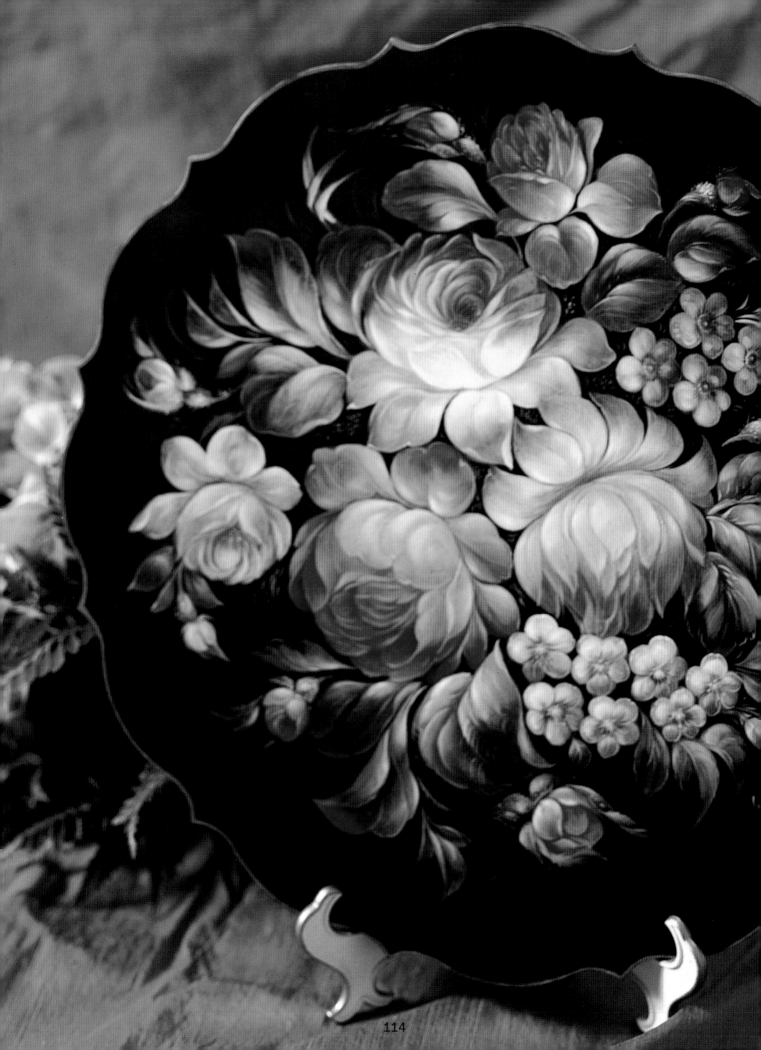

SYMPHONY OF FLOWERS

Симфония цветов

When you look at this design,
it seems as if all of the elements are
moving. They seem to be dancing
around the plate! You might
feel rhapsodic, as well, while you
paint it.

Symphony of Flowers PLATE

COLOR PALETTE

Alizarin Crimson
Asphaltum
Burnt Sienna
Cadmium Orange
Cadmium Red Deep
Cadmium Red Light
Cadmium Yellow Deep
Cadmium Yellow Light
Cadmium Yellow Medium
Prussian Blue
Sap Green
Viridian
White
Metallic Copper

OTHER SUPPLIES

Acrylic Craft Paints:
 White
Brush-on or Spray Paint:
 Flat black
Brushes:
 Small (#2, #4, or #6)
 Medium (#8 or #10)
 Large (#12 or #14)
 Liner, #1, 1/0, or scroll brush
Mediums:
 Turpenoid
 Linseed Oil
Painting Surface:
 Wooden Plate

PROJECT INSTRUCTIONS

See "A Painting Step-By-Step" and refer to the step-by-step photos in instructions for the "Rose Bouquet" project for help when painting the leaves, the coral roses, and the linework around this design.

Preparation:
1. Basecoat the plate by brushing or spraying on two or three coats of flat black paint. Let the paint dry and sand after each coat with very soft steel wool. Wipe off all of the residue with a tack cloth. Sand after the last coat with a crumpled piece of brown paper bag with no printing on it. Wipe with a tack cloth.
2. Seal with matte acrylic spray. Let dry. Rub lightly again with the brown bag. Wipe off all of the residue with the tack cloth.
3. Neatly transfer the design, using chalk.

Undercoating:
1. Undercoat the design with white acrylic paint, using the same strokes that you will use to paint the design.
2. Use a single edged razor blade to scrape the entire design. (Hold the razor blade straight up to keep from gouging the surface.)
3. Sand lightly with a brown paper bag.
4. Apply a very thin layer of linseed oil to the undercoating with a small piece of cotton cloth.

Leaves:
1. Brush Alizarin Crimson onto the leaf tips, the buds, and on the edges of the petals of the coral rose.
2. Apply Cadmium Yellow Deep to the centers of the leaves.
3. Blend softly where the two colors meet.
4. Brush-mix Sap Green +Viridian. Brush this mix over leaves, allowing some of the colors beneath to show through.
5. Define the veins down the center of the leaves with the Sap Green/Viridian mix.
6. Brush-mix Prussian Blue + White to make an ice blue mix.
7. Using a variation of the S-stroke, pull the ice blue mix in the lightest area of the leaves.
8. Brush on White highlights.
9. Thin the ice blue mix to a flowing consistency. Fill the liner brush with the thinned paint. Paint the broken linework on and around the leaves.

116

White Blossoms:

Refer to Small Blossoms Painting Worksheet.

1. Brush Cadmium Yellow Light in and around the center, letting a touch of it come onto each petal.
2. Shade two of the petal tips with Alizarin Crimson. Softly blend where the edges of the colors meet.
3. Shade the base of each petal with a little Sap Green. Add a touch of Sap Green on the outer edge of the three upper petals.
4. Mix Cadmium Red Light + White (a 1:4 ratio). Lightly stroke over each petal.
5. Overstroke the petals with White, using short strokes. Paint the lightest petals first.
6. Fill the liner brush with White thinned with a touch of linseed oil mixed with a touch of turpenoid. Make thin comma strokes around each petal as shown on the Blossom worksheet.
7. Touch the center with a dot of Cadmium Red Deep. Make smaller dots on each petal as shown on the worksheet. Make fine lines on each petal with thinned White. Add dots of White on the petals. Highlight the centers with a touch of Cadmium Yellow Light. Draw very fine lines that connect the dots on the petals to the center with the Cadmium Yellow Light.

Golden Blossoms:

1. Paint the center of the dark blossoms with Cadmium Yellow Deep.
2. Brush Sap Green around the center.
3. Brush-mix a touch of Cadmium Yellow Light + White. Pull short strokes on each petal toward the center. Put a touch of the mix into the center and outline the center.
4. Brush White highlights on the blossoms.
5. Pull lines of thinned Alizarin Crimson from the center onto each petal.
6. Make a C-stroke in the center with the Alizarin Crimson.

Coral Roses & Buds:

Refer to the step-by-step photos in "Painting a Rose" section, using colors given here.

1. Brush Cadmium Orange onto back section of the coral roses and buds.
2. Softly blend the edges where the two colors meet (Cadmium Orange and the Alizarin Crimson from the leaf section).

3. Brush on Cadmium Red Deep to form the petals on the shadow side of the large rose and around the outer edges of smaller rose and the buds.
4. Brush-mix Cadmium Orange + White and form the bowls of the roses, the front petals, and the fronts of the buds. Softly blend where the colors meet.
5. Add a little more White to the mix. Form the edges of the petals on the roses and the buds.
6. Using the White that's in the brush, paint the highlights on the lower petals.
7. Thin Cadmium Orange to a flowing consistency. Fill the liner brush and paint the linework on the smaller rose and bud.
8. Thin Cadmium Red Deep to a flowing consistency. Fill the liner brush and paint the tiny broken lines you see on the roses and even on a couple of the leaves.
9. Thin White to a flowing consistency. Fill the liner brush and paint the linework on the roses and the other buds.
10. Make a few dots of White in the center of the small rose.

Closed Yellow Rose & Yellow Buds:

1. Brush Asphaltum onto the outer edges of the large closed rose and on the yellow buds.
2. Brush Sap Green over the Asphaltum.
3. Brush on Cadmium Yellow Deep to form the petals on the rose and the buds.
4. Brush-mix White + a touch of Cadmium Yellow Light. Form the edges of the petals on the bowl of the rose and on the buds. Also stroke in the highlights on the lower petals.
5. Thin Cadmium Red Deep to a flowing consistency. Fill your liner brush and paint the tiny, thin lines on the rose and buds.

White Roses & Buds:

Refer to the step-by-step photos in "Painting a Rose" section, using colors given here.

1. Brush Asphaltum around the outer edges of both white roses and in their centers. Paint the outer edges of the white buds with Asphaltum.
2. Brush Alizarin Crimson into the center of the larger rose and around the edges of the back petals.
3. Brush a tiny amount of Cadmium Orange to begin to form the petals on the smaller rose and the buds.

Continued on next page

Continued from page 117

4. Brush Viridian over the outer edges of the larger rose and around the center, softly blending where the colors meet.

5. Brush-mix Viridian + White and form the petals around the larger rose and the buds.

6. Add more White and form the highlights on the petals on the front bowl of the larger rose. (This is the lightest portion of the rose.)

7. Use the lightest mix to form the petals on the smaller white rose and the buds.

8. Thin White to a flowing consistency. Fill the liner brush and add dots to the center of the smaller rose and the calyxes of the buds.

9. Thin Cadmium Red Deep to a flowing consistency. Paint the thin linework on the roses.

Linework:

Thin Viridian + a touch of White to a flowing consistency. Paint the grass-like linework around the design.

Border:

For this border just take Metallic Copper on your finger and rub the edge of the plate with your finger. This will make the band around the edge. ❏

Pattern for Symphony of Flowers Plate

Enlarge pattern @130% for actual size.

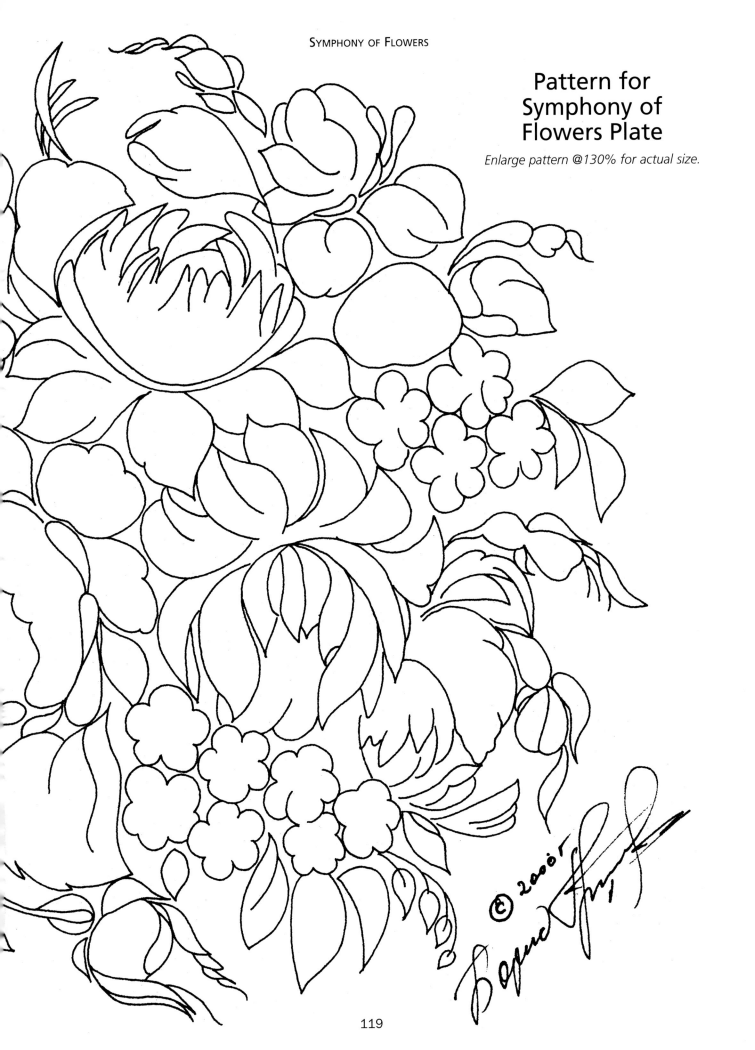

HIDDEN ROSE

Прячущая роза

Very seldom do you see the backside
of a rose as a painting subject but it,
too, is beautiful, with its colors muted
somewhat by the green of the stem
and calyx. The back of the rose is seen
in many Zhostovo designs. Even
when painted alone, it is very striking.

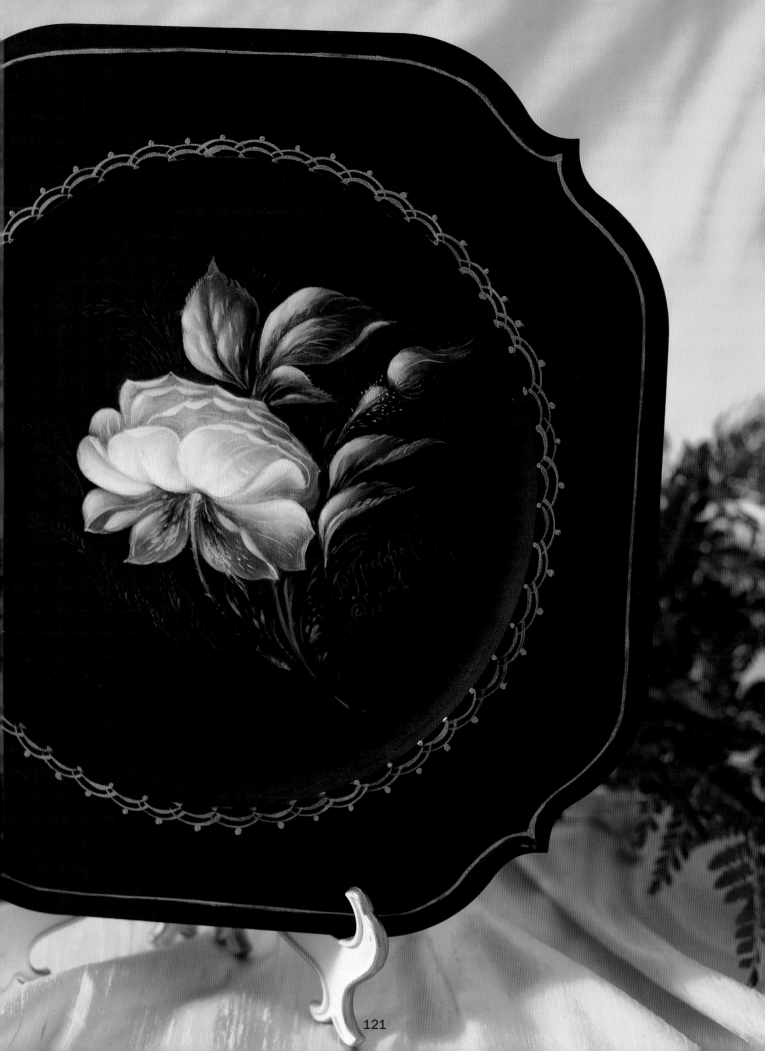

Hidden Rose PLATE

COLOR PALETTE

Alizarin Crimson
Asphaltum
Black
Cadmium Orange
Cadmium Red Light
Cadmium Yellow Light
Prussian Blue
Sap Green
Viridian
White
Metallic Gold

OTHER SUPPLIES

Acrylic Craft Paints:
 Black
 White
Brushes:
 Small (#2, #4, or #6)
 Medium (#8 or #10)
 Large (#12 or #14)
 Liner, #1, 1/0, or scroll brush
Mediums:
 Turpenoid
 Linseed Oil
Painting Surface:
 Wooden Plate

PROJECT INSTRUCTIONS

Preparation:

1. Basecoat the plate by brushing on two or three coats of black acrylic paint. Let the paint dry and sand after each coat with a crumpled piece of brown paper bag with no printing on it. Wipe off all of the residue with a tack cloth. Sand after the last coat with a crumpled piece of brown paper bag. Wipe with a tack cloth.
2. Seal with matte acrylic spray. Let dry. Rub lightly again with the brown bag. Wipe off all of the residue with the tack cloth.
3. Neatly transfer the design, using chalk.

Undercoating:

1. Undercoat the design with white acrylic paint, using the same strokes that you will use to paint the design.
2. Use a single edged razor blade to scrape the entire design. (Hold the razor blade straight up to keep from gouging the surface.)
3. Apply a very thin layer of linseed oil to the undercoating with a small piece of cotton cloth.

Rose:

Refer to Back of Rose Painting Worksheet.

1. Apply a touch of Alizarin Crimson to the lower petals as shown on the worksheet.
2. Brush Cadmium Orange over the top of these petals.
3. Brush a small amount of Sap Green on the other petals as illustrated.
4. Mix Cadmium Red Light + White (a 1:1 ratio) and overstroke the petals with the red tips.
5. Mix Prussian Blue + White (a 1:10 ratio) to make an ice blue mix. Overstroke the remaining petals, starting with the lightest areas.
6. Using the ice blue mix, form the edges of the petals to create turns as shown in illustration C.
7. Apply all the White highlights as illustrated.
8. Mix Viridian + a touch of Black to paint the stem and calyx area.
9. Shade the lower portion of the stem with Alizarin Crimson.
10. Mix Cadmium Yellow Light + the ice blue mix to highlight the stem and the calyx area.
11. Thin White with turpenoid and linseed oil to a thin consistency. Using the contour of a filbert brush and the thinned White paint, apply short touches on one petal for highlights.
12. Fill the liner brush with the thinned White paint and add delicate linework around and on the petals.

Bud:

1. Apply Asphaltum to the tip.
2. Brush Cadmium Yellow Light where the bud meets the calyx.
3. Brush over the yellow with Sap Green.
4. Brush Viridian + Black (a 10:1 ratio) over the shadow side of the bud and on the right side of the calyx.
5. Mix Sap Green + Cadmium Yellow Light + White to make an ice green mix. Fill in the area near where the bud and the calyx join with this mix. With a very light touch, stroke over the rest of the bud to softly blend the colors.

6. Using White, stroke in the highlights as shown in the photo of finished project.

7. Use the ice green mix to paint the linework on the bud.

8. Add a little more White to the ice green mix and make dots and tiny strokes on the calyx.

Leaves:

1. Apply Asphaltum on the leaf tips.

2. Brush Cadmium Yellow Light about two-thirds of the way up the leaf and lightly blend.

3. Brush over the yellow with Sap Green. Define the vein with Viridian + a touch of Black. Apply a tiny touch of Viridian plus Black to the tips as well as the base of the leaves.

4. Mix Sap Green + Cadmium Yellow Light + White to make an ice green mix. Fill in the area near the stem with this mix, using a variation of the S-stroke. With a very light touch, stroke over the rest of the leaf to softly blend the colors together.

5. Using White, stroke in the highlights as shown in the photo of the finished project.

6. Fill an excellent liner brush with the thinned ice green mix. Carefully paint the broken linework around the leaves.

7. Add a touch of Viridian to the ice green mix. Paint the grass-like linework around the design.

Border or Ornamentation:

1. Fill an excellent liner brush with Metallic Gold thinned to a flowing consistency with linseed oil and turpenoid.

2. Paint the border of your choice around the plate. ❑

Pattern for Hidden Rose Plate

(actual size)

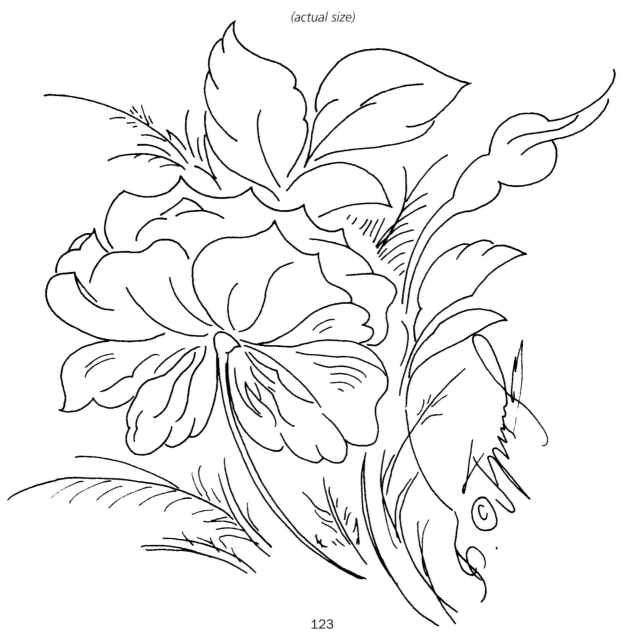

Hidden Rose Painting Worksheet

Illus. A

1. Undercoat with white acrylic paint. Let dry.
2. Rub on a thin layer linseed oil.

Illus. B

1. Apply Alizarin Crimson to lower petals.
2. Brush Cadmium Orange over the petals.
3. Brush on Sap Green as illustrated.

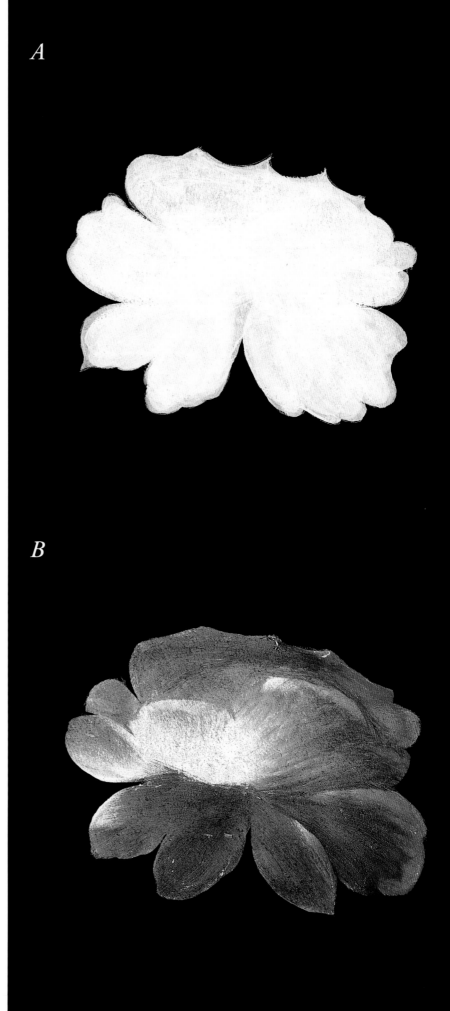

124

C

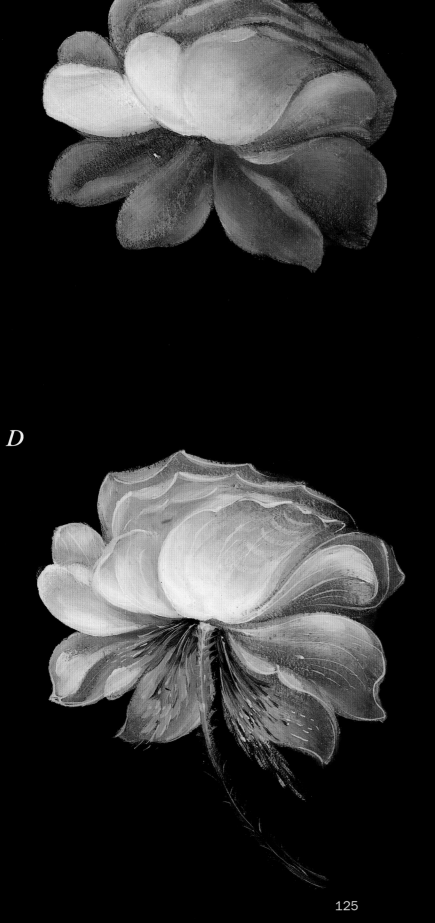

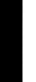

D

Illus. C

1. Mix Cadmium Red Light + White to overstroke red petals.
2. Mix Prussian Blue + White to overstroke remaining petals. Start with lightest petals.
3. Use Prussian Blue/White mix to form petal edges to create turns.

Illus. D

1. Apply White highlights.
2. Paint stem and calyx area with Viridian + Black.
3. Shade lower portion of stem with Alizarin Crimson.
4. Highlight stem and calyx with Cadmium Yellow Light + ice blue mix.
5. Touch filbert brush filled with White to large petal for highlight.
6. Linework – thinned White paint.

Metric Conversion Chart
Inches to Millimeters and Centimeters

Inches	MM	CM		Yards	Meters
1/8	3	.3		1/8	.11
1/4	6	.6		1/4	.23
3/8	10	1.0		3/8	.34
1/2	13	1.3		1/2	.46
5/8	16	1.6		5/8	.57
3/4	19	1.9		3/4	.69
7/8	22	2.2		7/8	.80
1	25	2.5		1	.91
1-1/4	32	3.2		2	1.83
1-1/2	38	3.8		3	2.74
1-3/4	44	4.4		4	3.66
2	51	5.1		5	4.57
3	76	7.6		6	5.49
4	102	10.2		7	6.40
5	127	12.7		8	7.32
6	152	15.2		9	8.23
7	178	17.8		10	9.14
8	203	20.3			
9	229	22.9			
10	254	25.4			
11	279	27.9			
12	305	30.5			

INDEX

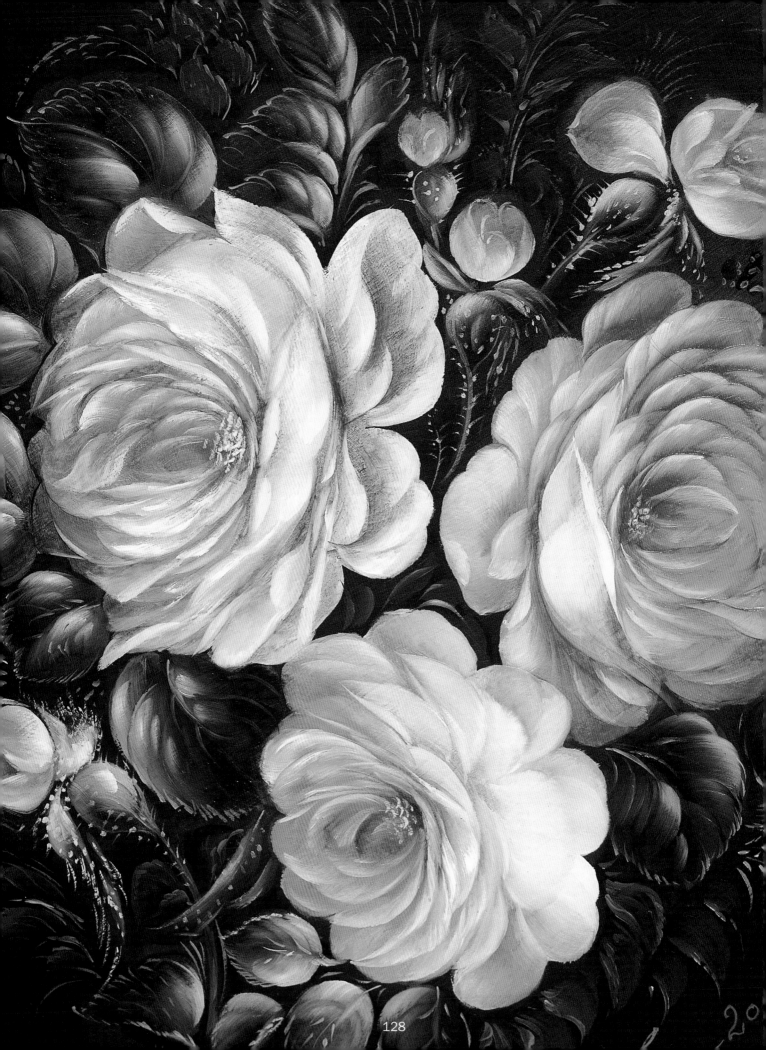

128